STOKES CROFT & MONTPELIER

STOKES CROFT & MONTPELIER

COLIN MOODY

First published 2018

The History Press
The Mill, Brimscombe Port
Stroud, Gloucestershire, GL5 2QG
www.thehistorypress.co.uk

British Library Cataloguing in Publication Data.
A catalogue record for this book is available from the British Library.

ISBN 978 0 7509 8774 5

Typesetting and origination by The History Press
Printed in China

INTRODUCTION

'But I'm not from Stokes Croft,' said the guy in the bar when I asked if I could take his photograph. He beamed a rebellious smile at me, leaned over and told me why he loves coming here to play in his band. He has been drawn into the mix as I have been. The people of Stokes Croft and Montpelier: interweaving, intersecting and overlapping in images taken between early 2016 through to January 2018. They are at the core of this book.

Being outside Bristol's city walls, Stokes Croft and Montpelier have been places where the less established elements of society have thrived for centuries. An early report from the 1820s describes local residents as 'a surprisingly diverse range of tenants', and recently I've heard the area called a 'fusion of a lot of different ideas'. The vibrancy of the area today has guided me to tell stories of this unique community using a variety of photographic techniques.

There are new layers of stories unfolding every day; there is a kind of human geology at work here. One person passing through might see a particular spot as an architectural wasteland, while another longer-standing resident might see the same area as their village green. As a photographer, I am excited to see beyond what appears on the view finder.

Much of what I love in social documentary photography follows on from the work of Henri Cartier-Bresson, Bruce Davidson and Jane Bown. The new lightweight cameras they used offered a lot of creative freedom, allowing the images to become a poetry of visual elements. It freed up the picture, taking us to a new place. These pioneering photographers took understated shots revealing life away from the main thoroughfares. Their images and the treatment of the subject have been a great influence on me and I would encourage everyone to revisit their work.

I believe that connecting with new people and places is more important than ever, and photography has the power to take us outside of our comfort zone and to challenge us to look deeper into our communities. Choosing to turn away from the crowd in order to go down an unfamiliar side street can be its own reward for any photographer.

This book would not have been possible were it not for the generosity, welcome and support of the people of Stokes Croft and Montpelier. Thank you.

ABOUT THE PHOTOGRAPHER

Colin Moody's interest in photography began when he studied graphic media design at the London College of Printing and Distributive Trades. After graduating he worked in film and TV as an art department assistant, working on films including *Bridget Jones' Diary*, *Mona Lisa Smile* and *Last Orders*. Eventually, a change was needed and he became a presenter working with event companies. Colin moved to Bristol in 2009 and the presenting work dried up. He felt the need to do something with the enforced spare time. He began exploring the streets of Bristol, iPhone in hand, and photographed what stood out for him: people, mostly.

Bristol is a city endlessly inventing new ways to live, collaborate and express itself. That's what Colin is drawn to. His style is born out of – and fuelled by – a Bristol way of seeing.

Colin's photography has been published in national and local newspapers and magazines, such as *Bristol Life*, *The Bristol Magazine*, *Bristol 24/7* and *The Bristol Cable*. He likes to work with media that has a strong desire to share the bigger picture and present a diverse range of stories.

'In a city blessed with more than its fair share of outstanding photographers, Colin Moody is a stand out. His work transcends mere technique; Colin sees humanity, humour and poignancy in the everyday scenes that pass most of us by. You can always tell a Colin Moody photo before you see the name – it's the one that makes you look twice, smile, and take something away from the image you've just seen. There's a kindness and empathy in his photos, mixed with a mischievous sense of fun, that makes him unique in our books. He is *the* Bristol photojournalist.'

Deri Robins
Editor Bristol Life Magazine – *Media Clash*

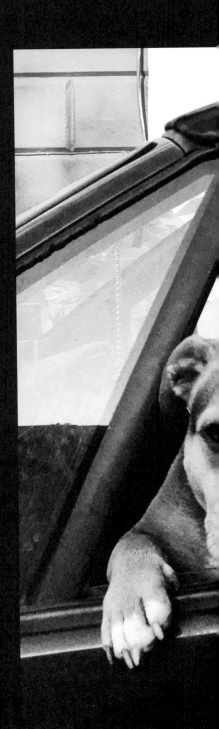

The Dogs of Picton Street

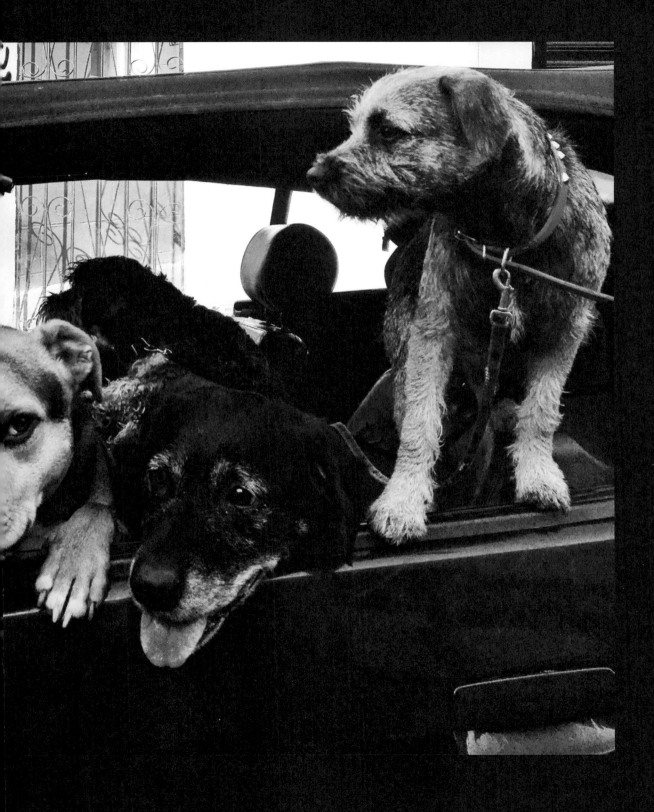

'Ladies, we are not in Clifton anymore'

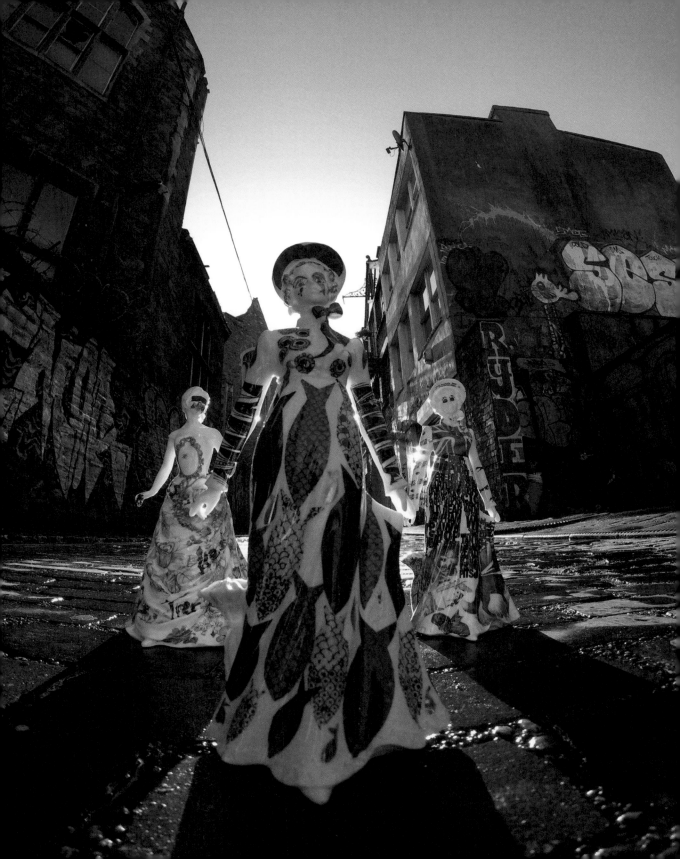

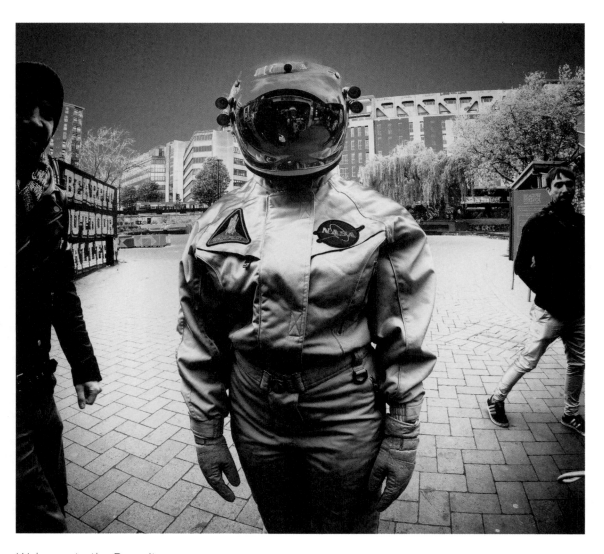

Welcome to the Bearpit

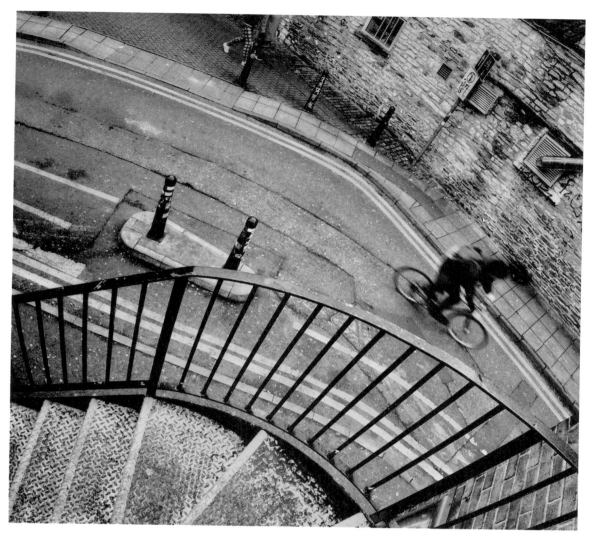

Side-street cycle bottleneck

Graffiti tool box. 'I write my name
because nobody else is going to.'

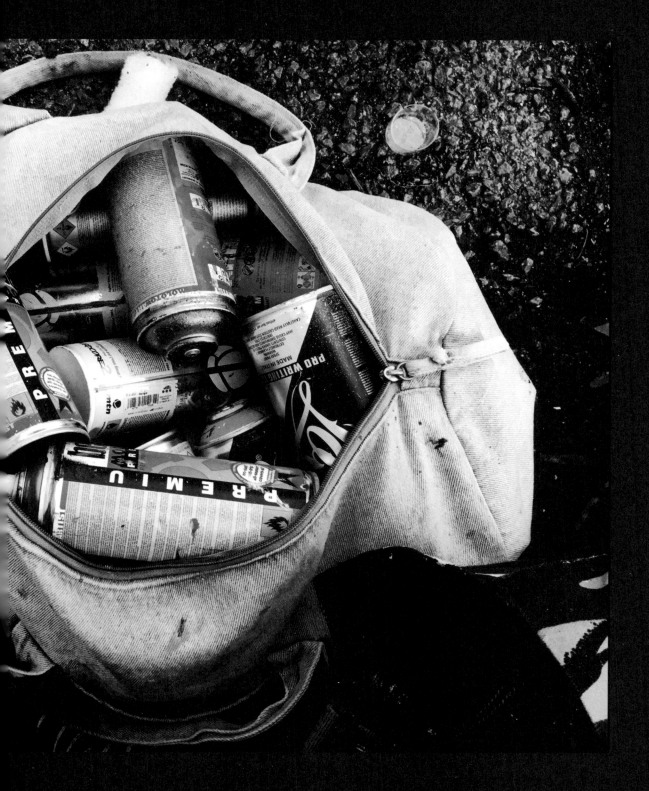

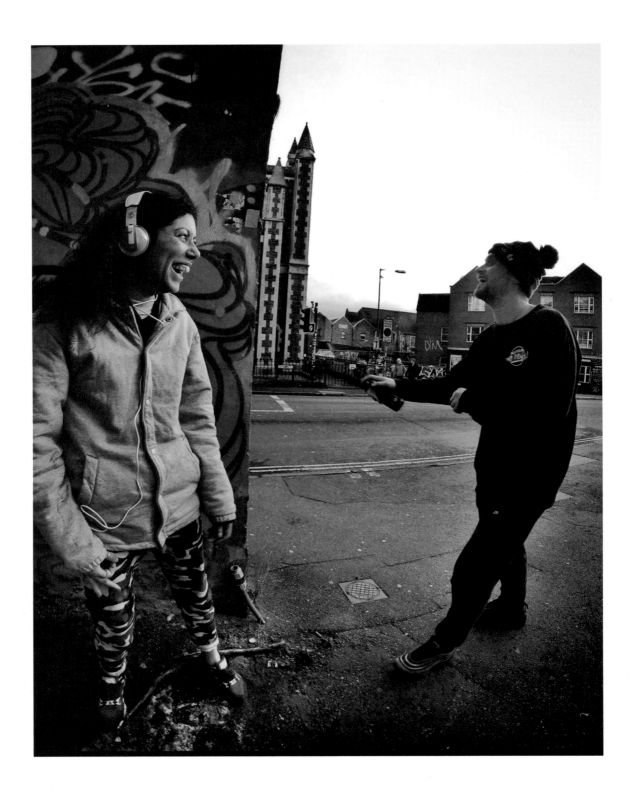

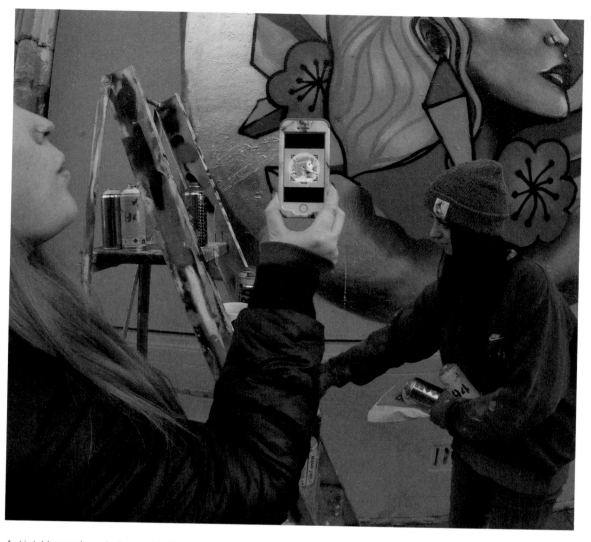

Artist Hazard and singer Katie Sky. Ladder from People's Republic of Stokes Croft

Opposite: Sneak Pekoe and friend, finishing rewriting Stokes Croft letters on the City Road wall

Bomber Jacket

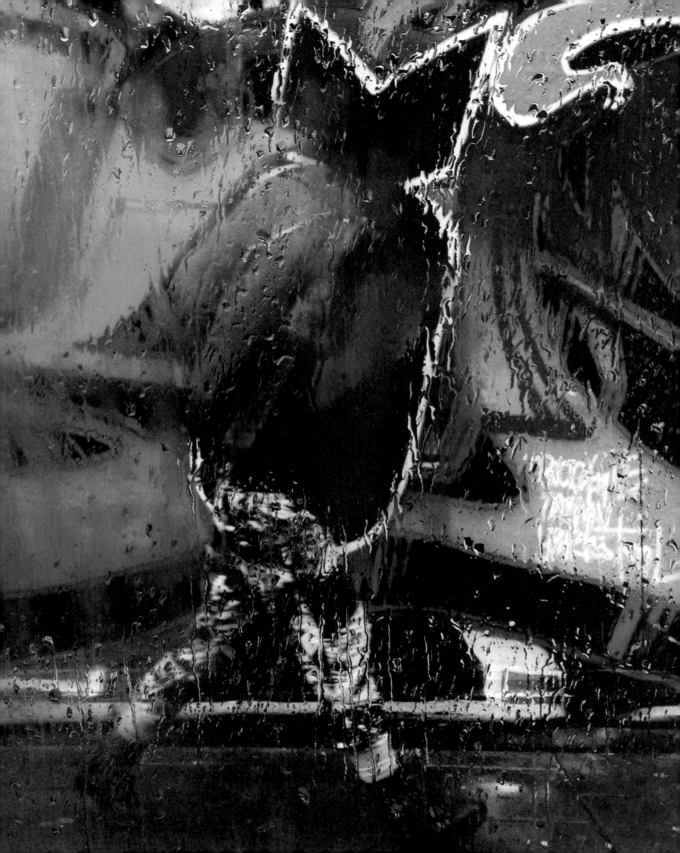

The Kiss

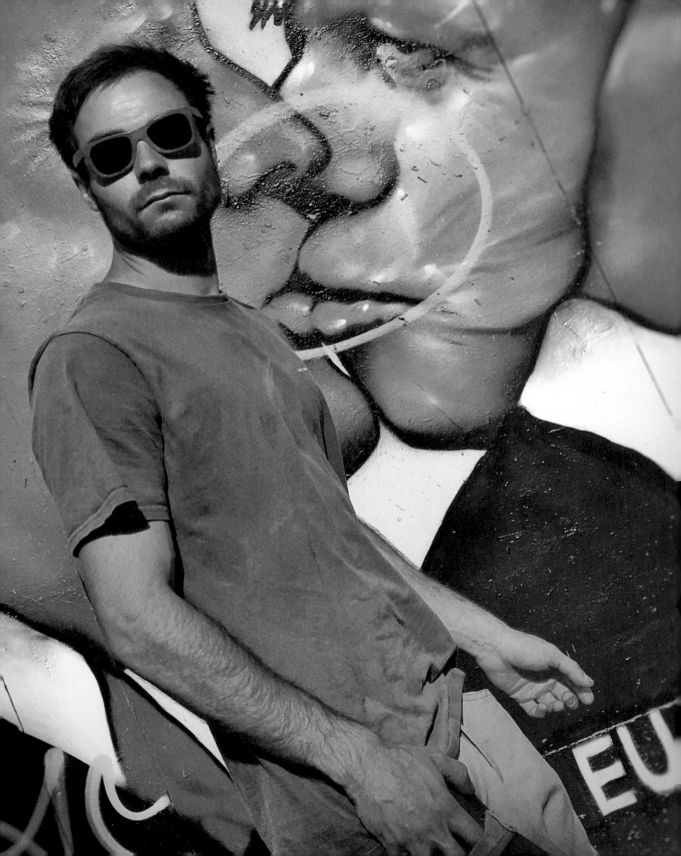

Opposite: Photographing the photographers photographing the people passing by. 'Very Stokes Croft.' said a friend via Instagram

Overleaf: Words build a bridge

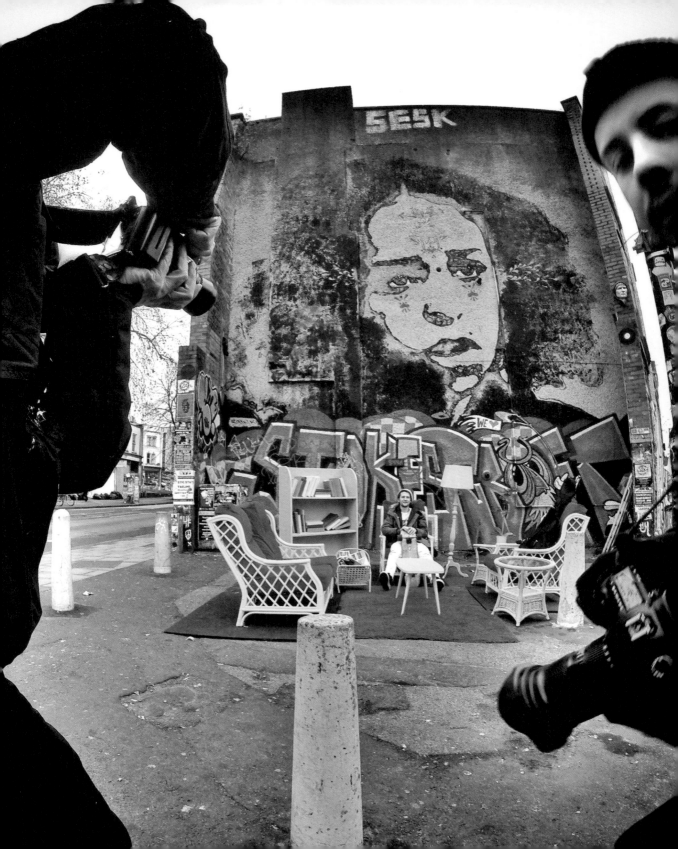

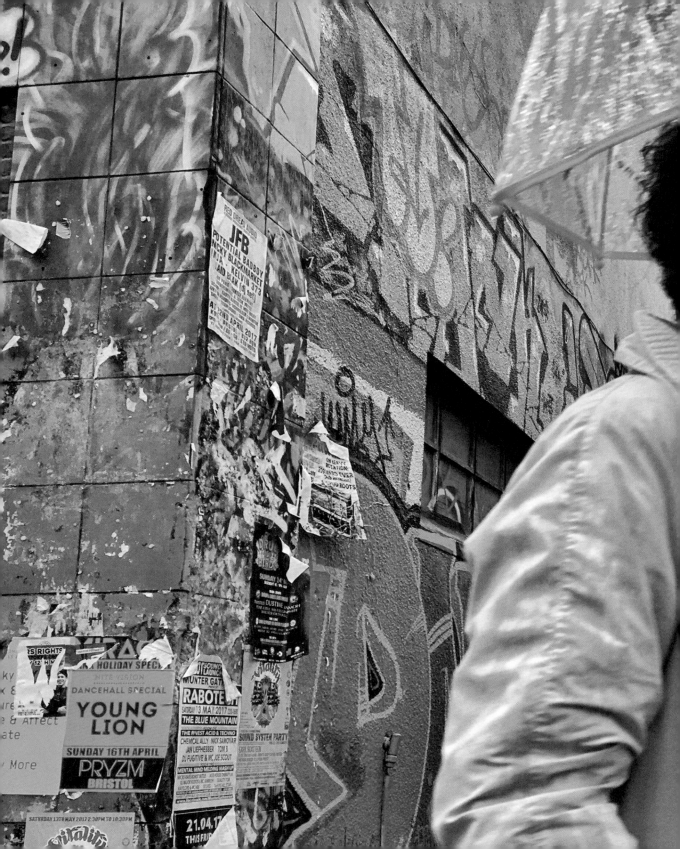

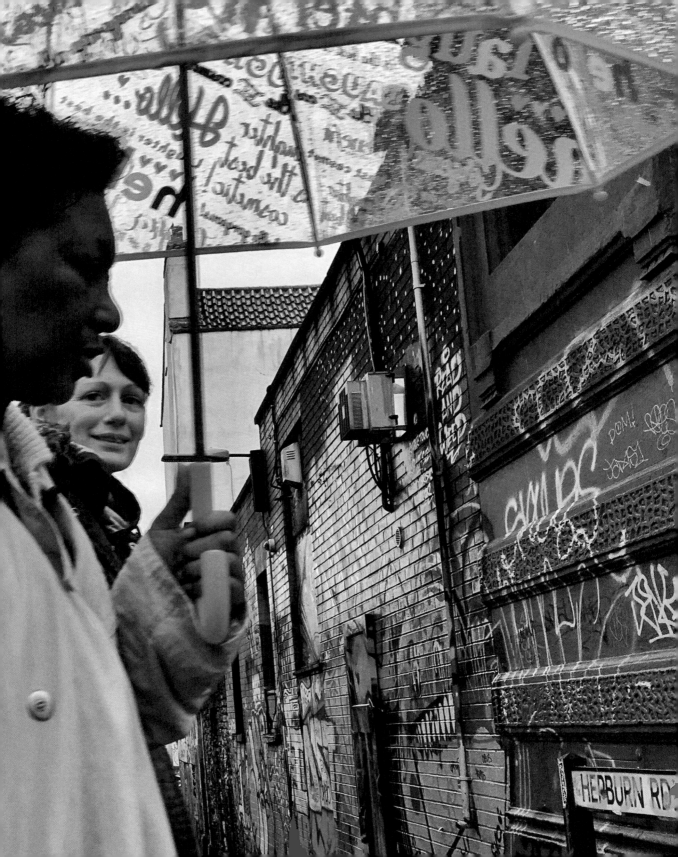

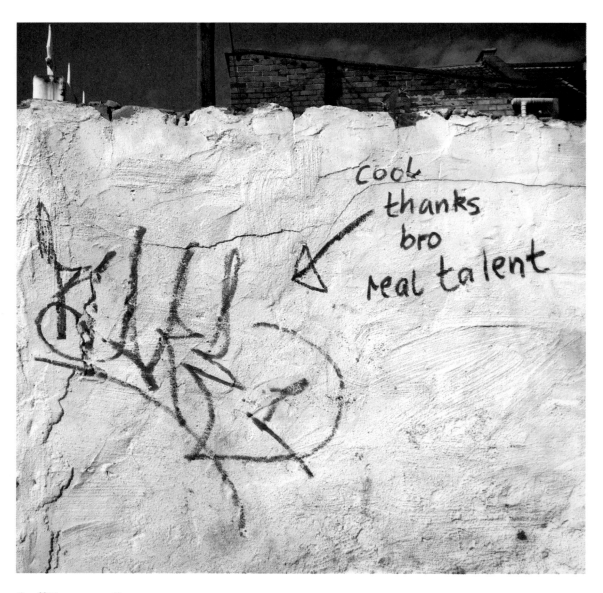

Graffiti conversation

Opposite: The Thinker

Jesus photobomb

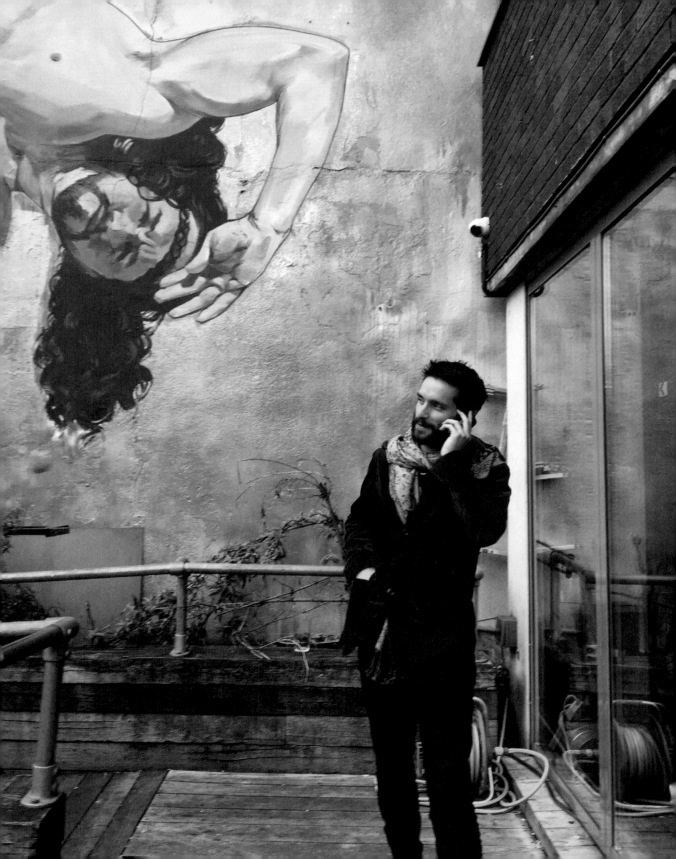

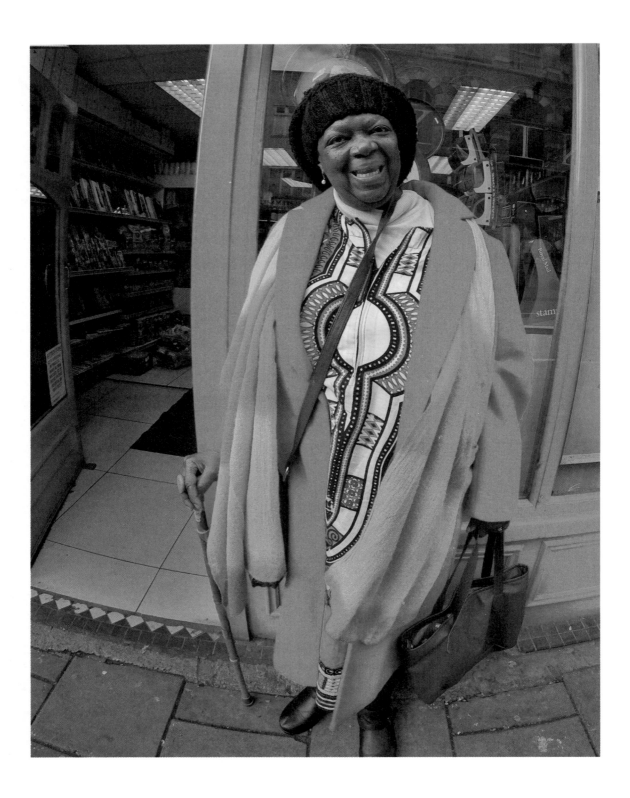

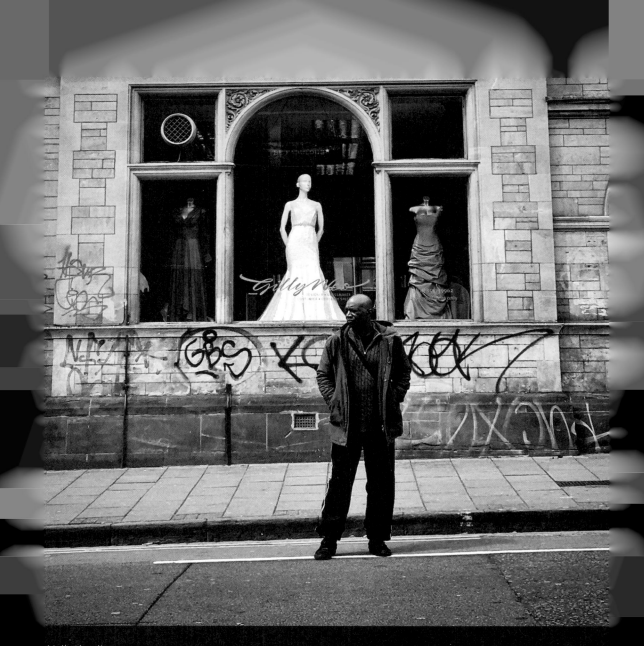

Walk the line

Opposite: Paulette of Montpelier: 'Why is everyone on their phones all the time?

Framed. Hamilton House

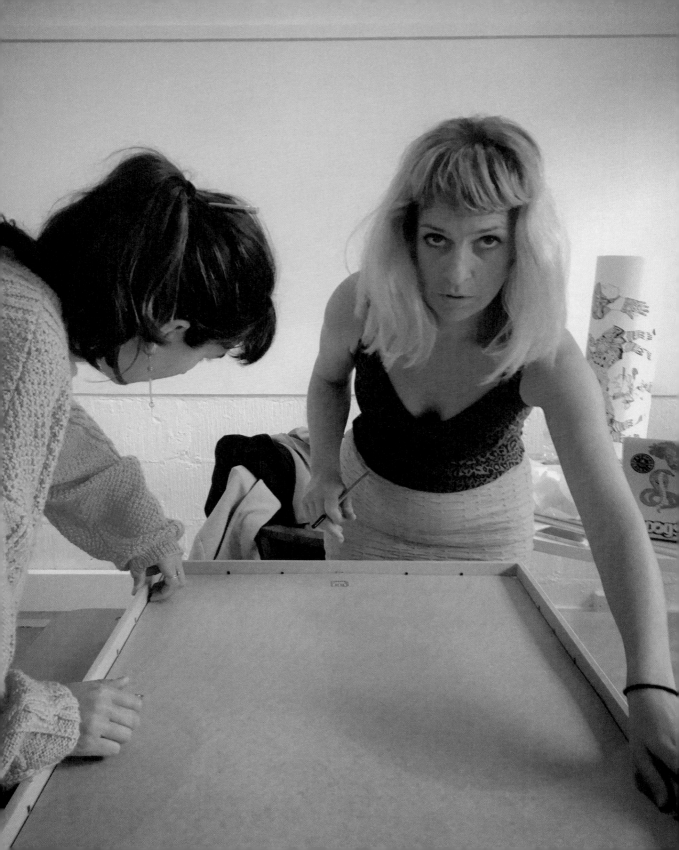

Stokes Croft and St Paul's border

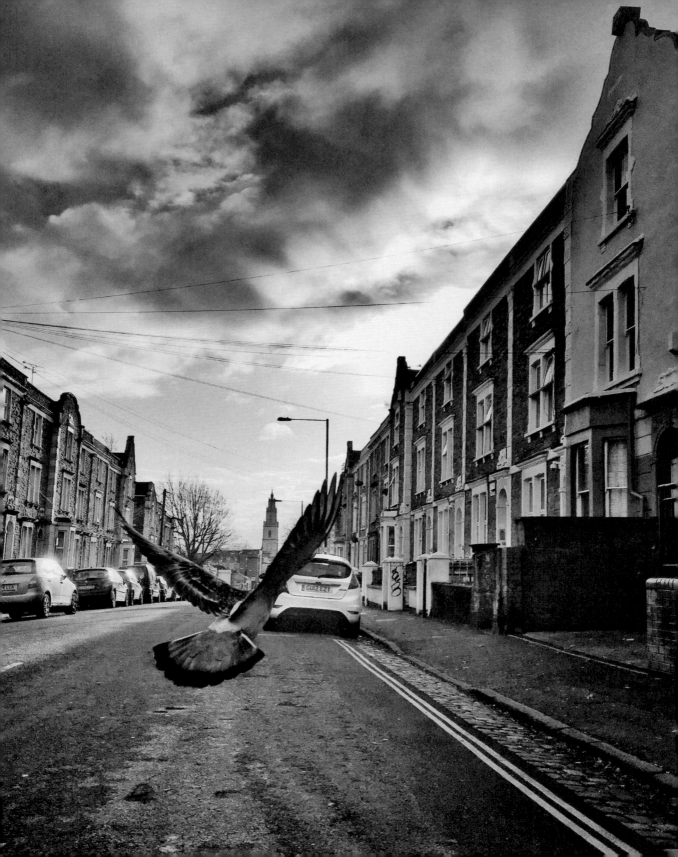

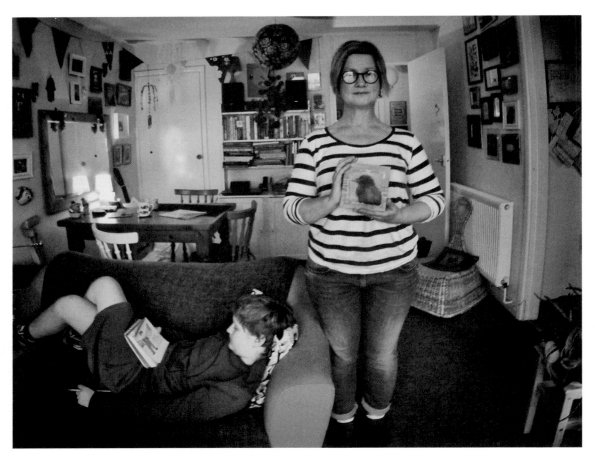

Phoebe lives here with her son. Both artists. She snaps birds and they make art from her high flat

Opposite: Jeff. I believe if we had a few more Jeffs, there would be nothing we could not achieve

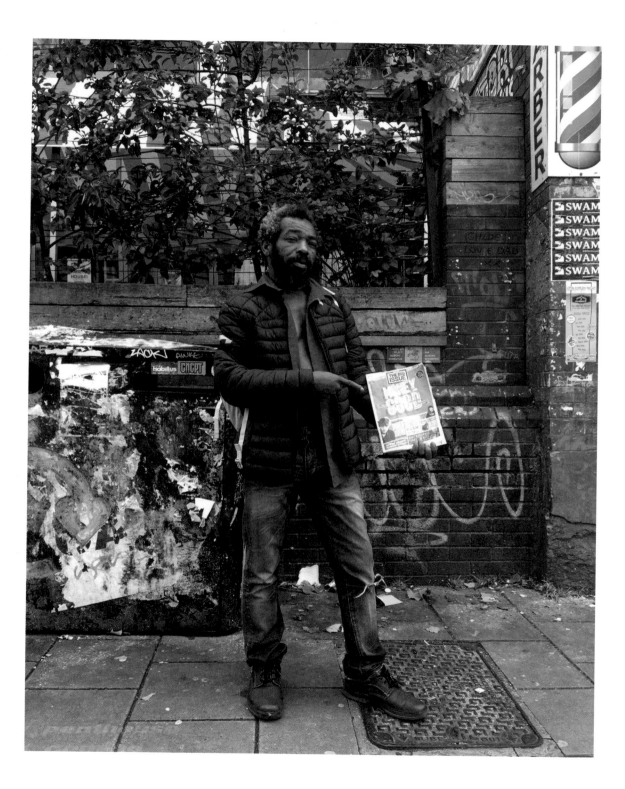

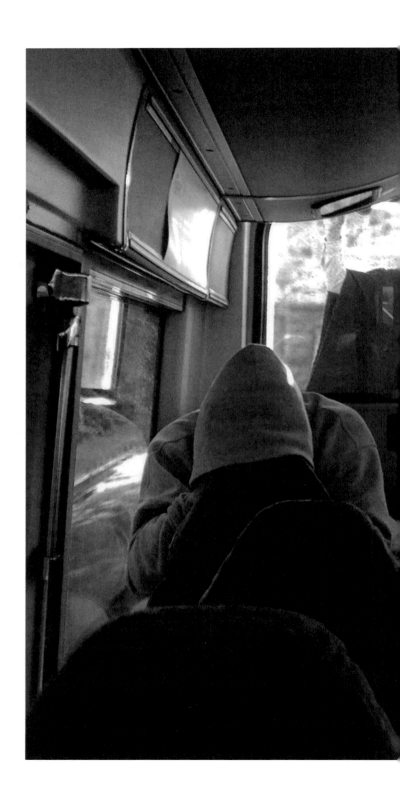

Passing through. Ad graduates celebrate, but not all passengers are feeling it

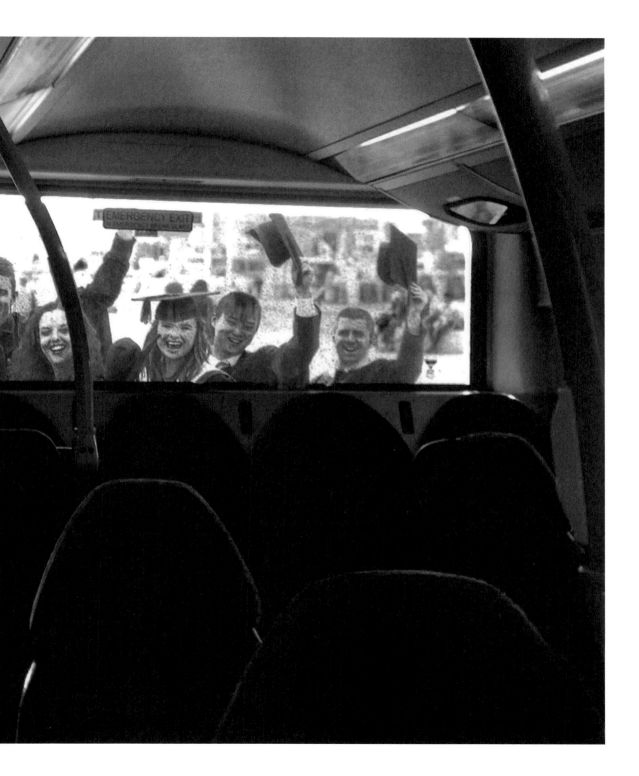

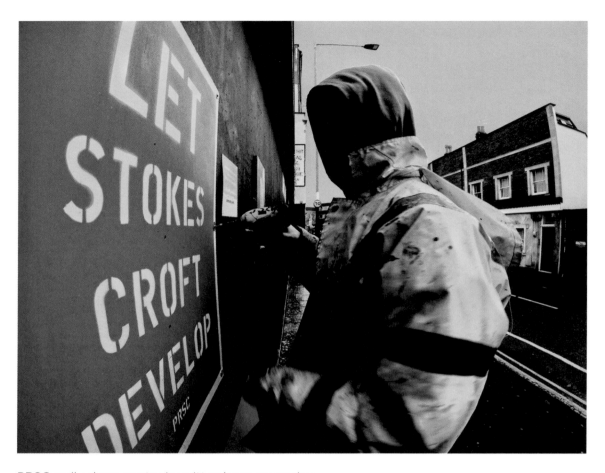

PRSC wall, where poetry is written large every day

Opposite: Studio 7 singers taking a break

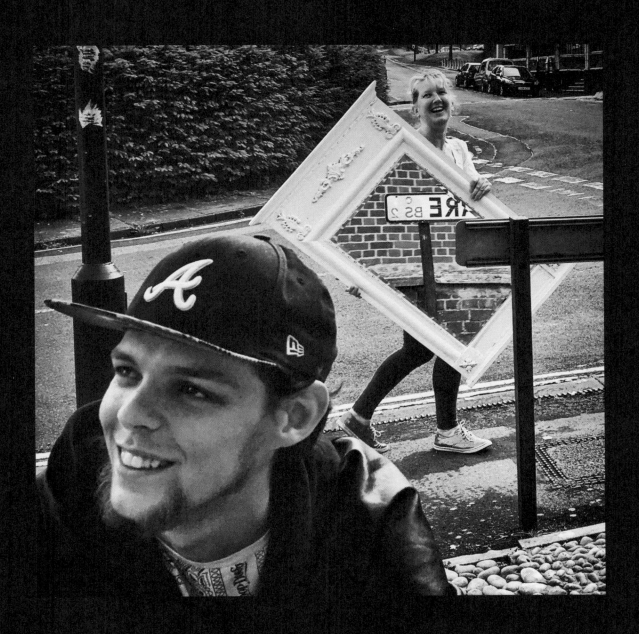

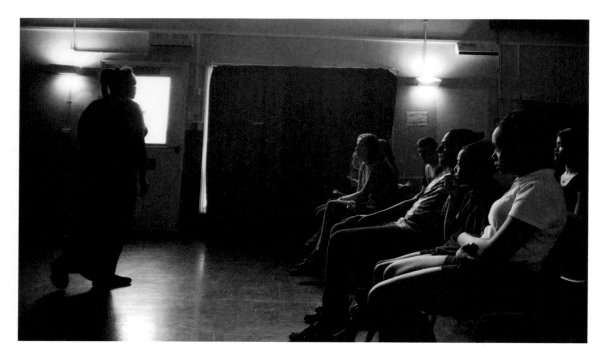

Kizzy Morrell starting the weekly Studio 7 singing rehearsals

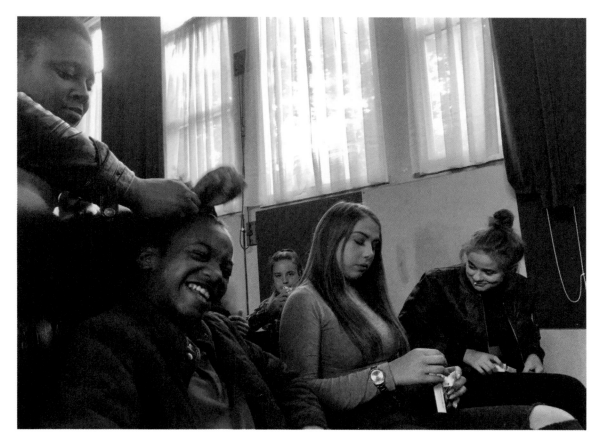

Sinairie having her hair done by her mother, Tracy. Also Finley, Victoria and Tia ahead of stage-craft practice

Studio 7. Natalie waits for her singing audition

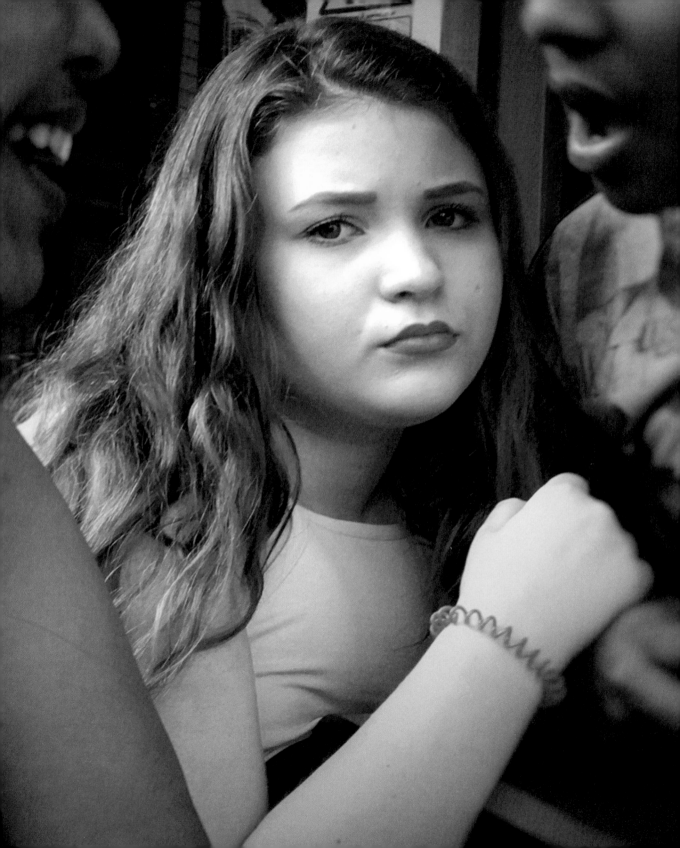

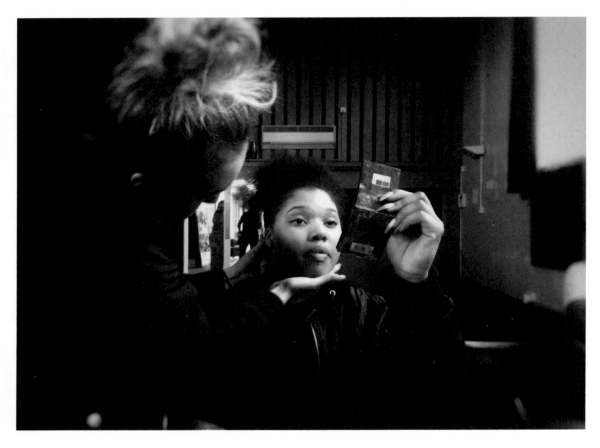

Studio 7. Angel doing Shannon's make-up

Opposite: Sinairie sings solo. No microphone. Sun gap in curtains provides her spot light

Overleaf: Amy in impromptu fashion shoot during fag break

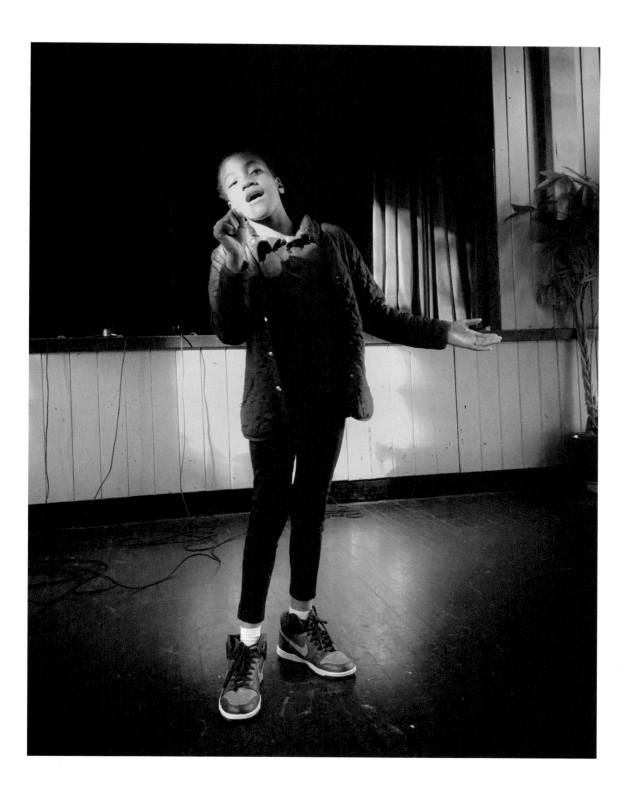

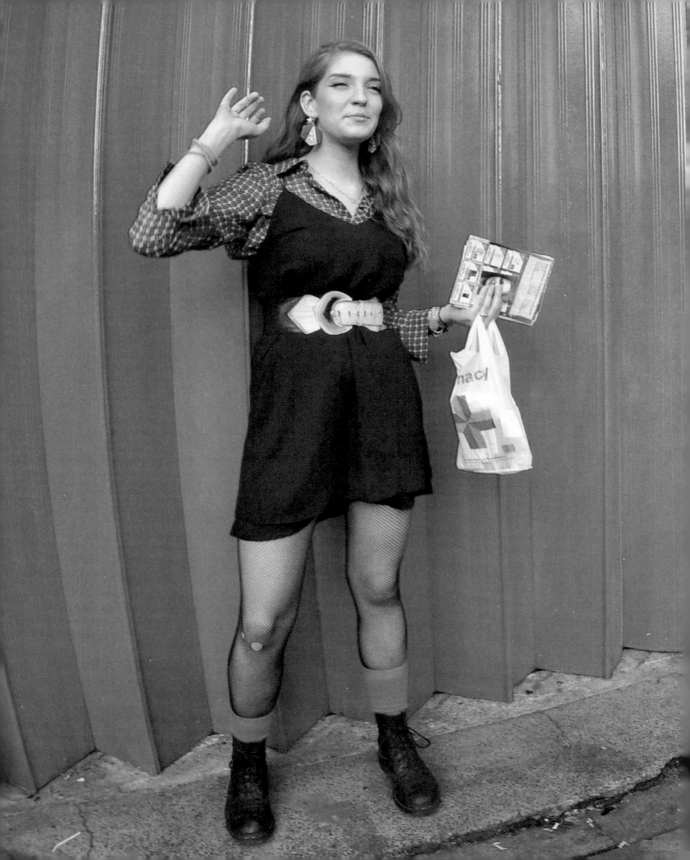

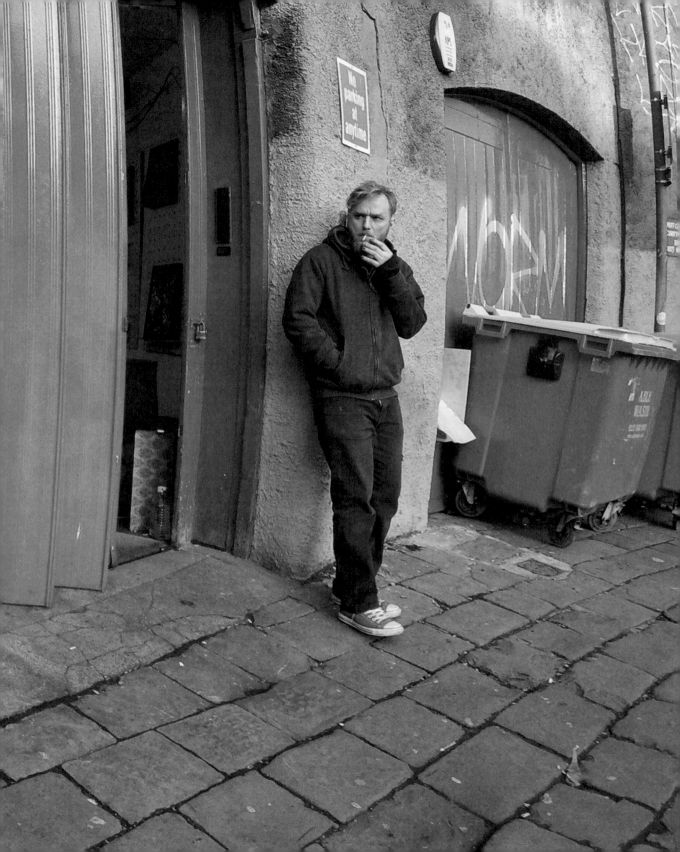

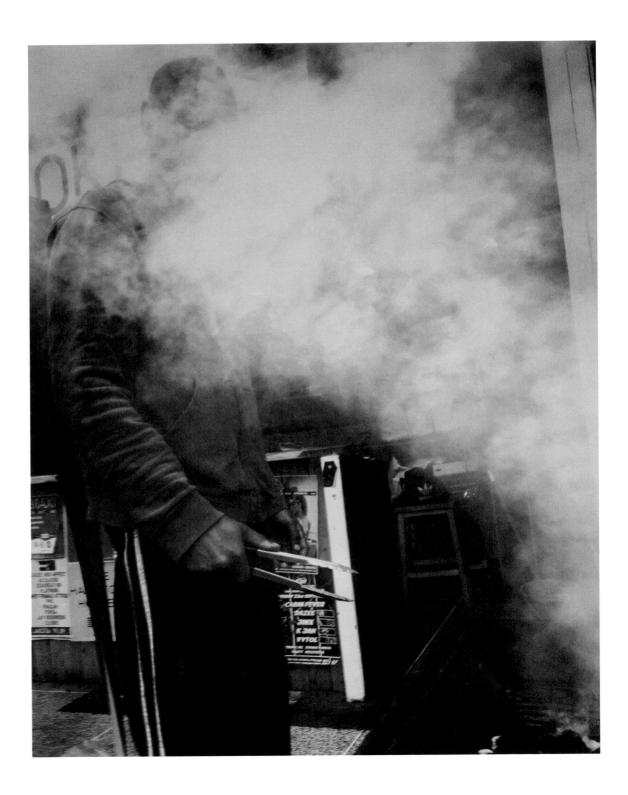

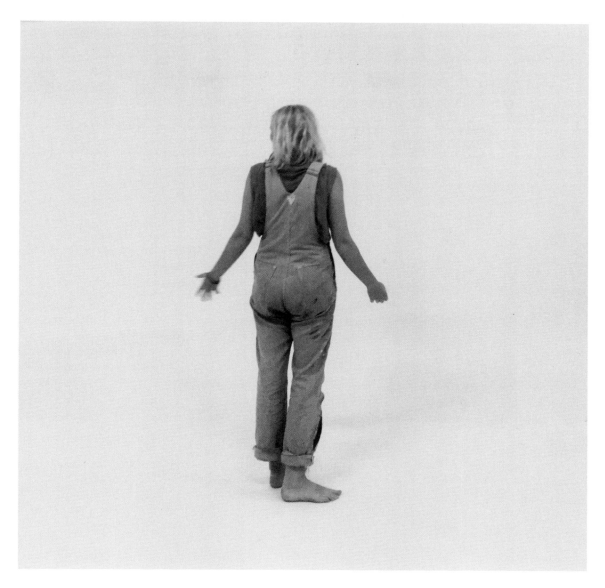

Victoria enters a studio space. Infinite artistic possibilities

Opposite: Jerk chicken, ready in 5 minutes

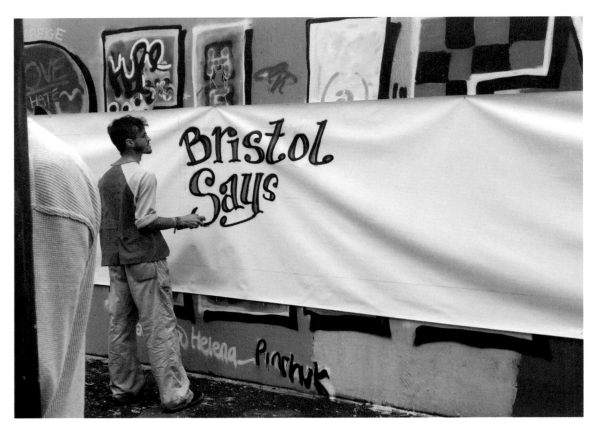

'Bristol Says' ... Front banner prepared for a protest march. People's Republic of Stokes Croft yard

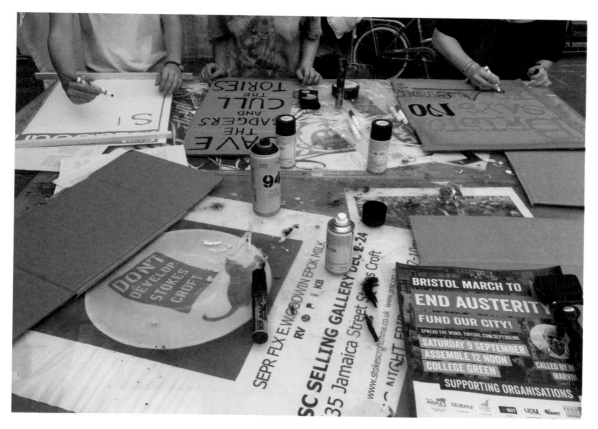

'End Austerity' protest production line

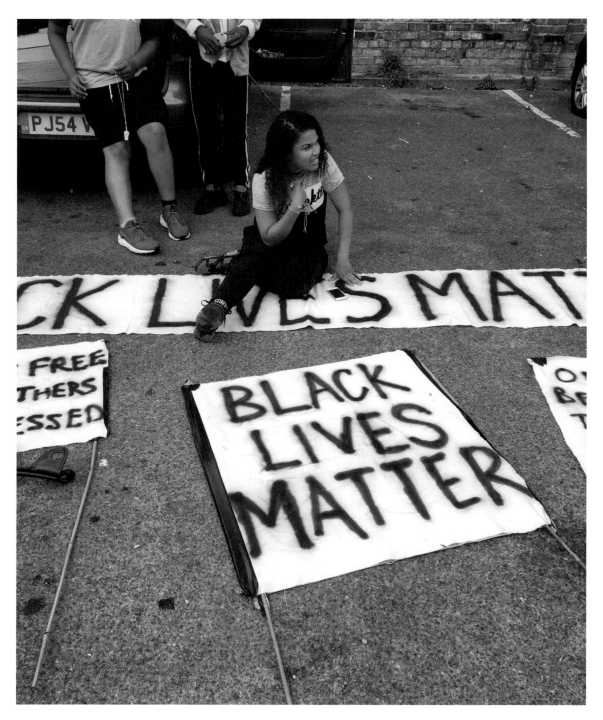

Black Lives Matter march, July 2016. Malcolm X Centre

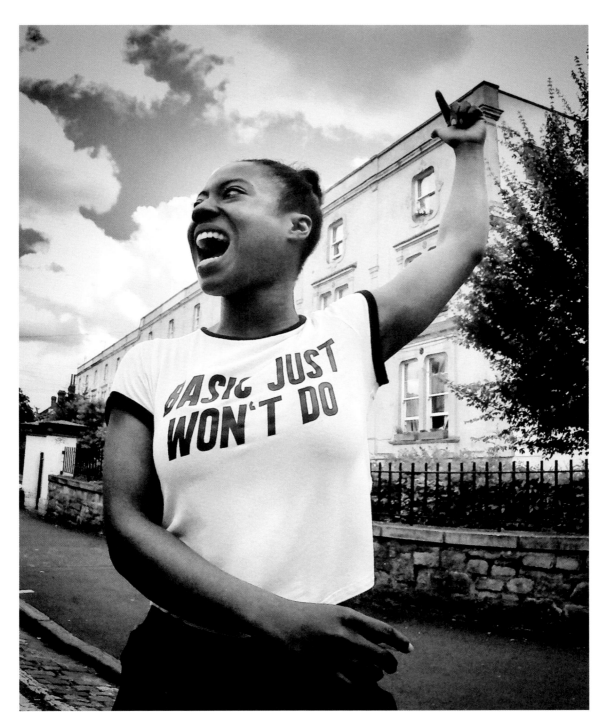

Black Lives Matter. Basic Just Won't Do

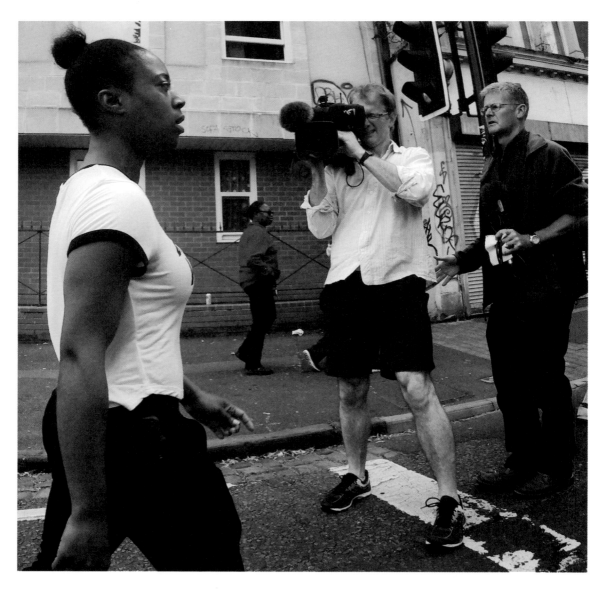

Local TV media crew get the shot before leaving the area

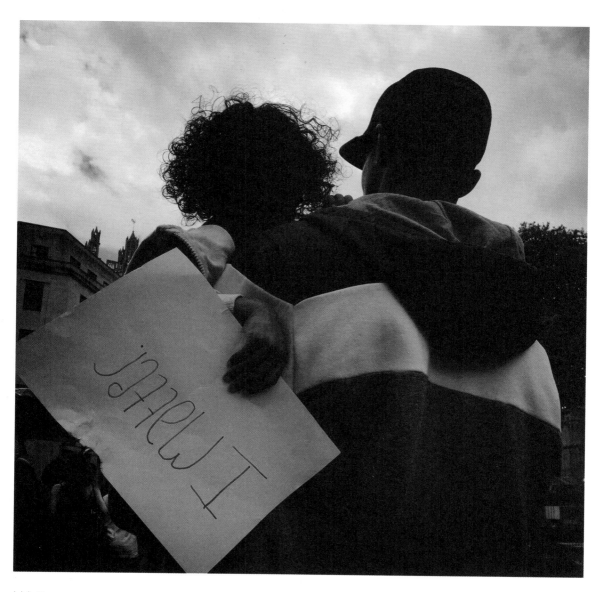

I Matter

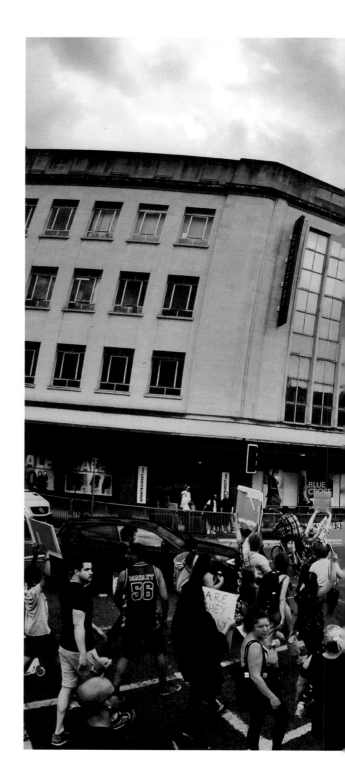

Right: Bear covering its face with one paw.
Black Lives Matter march passing by

Overleaf: Nina and friend. Aerial dancers
at the Albany Centre, Montpelier.
Former church

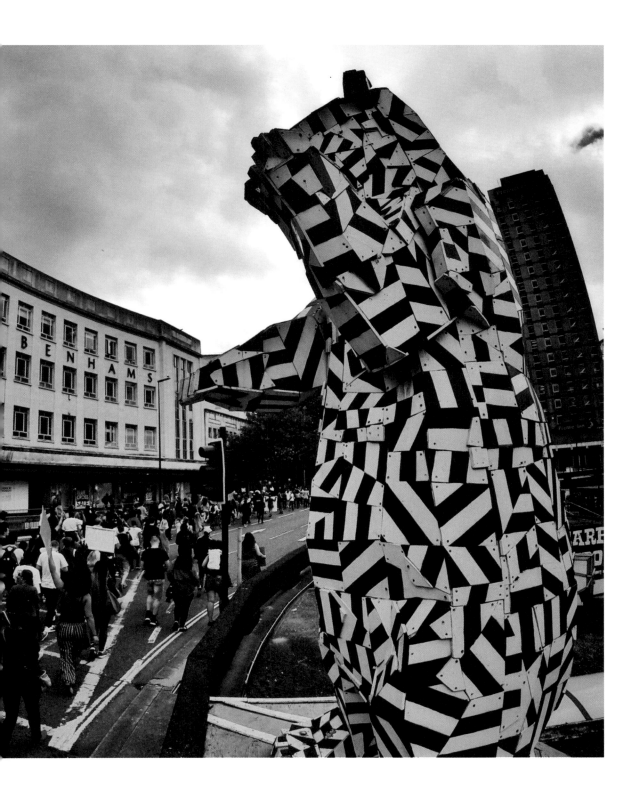

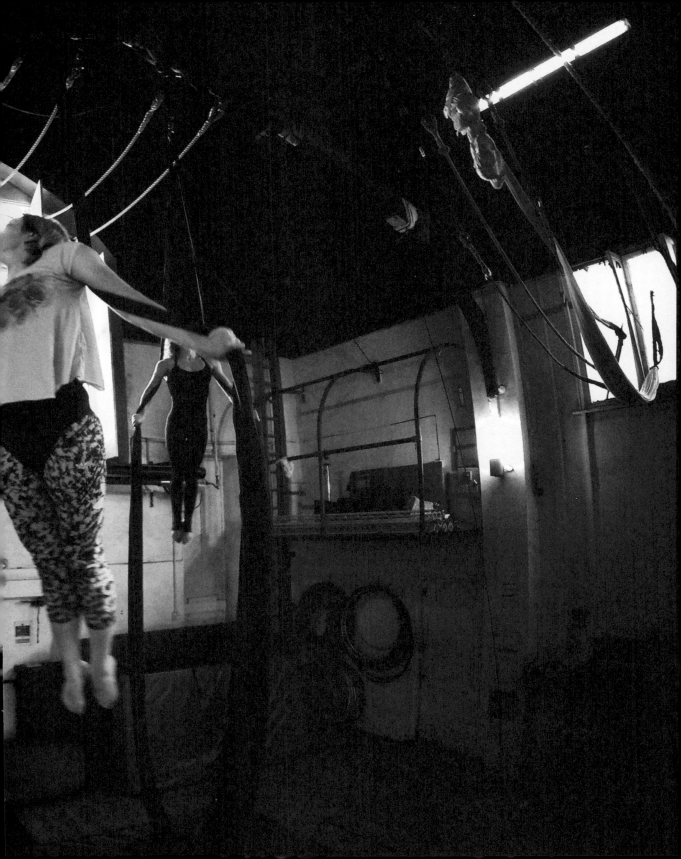

Sapphire on the Gloucester Road, heading to Stokes Croft in no particular hurry. 'I adore Bristol.'

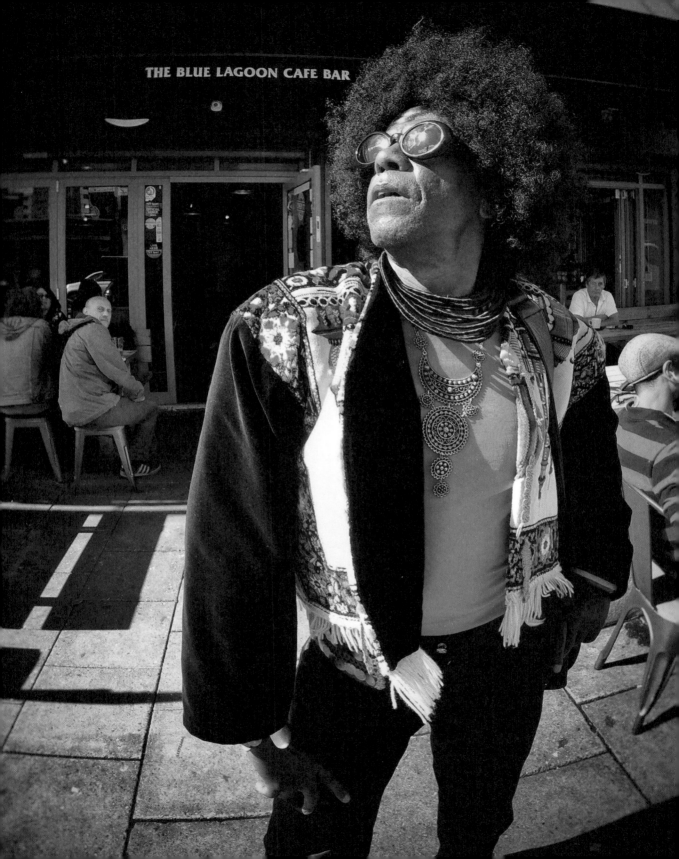

Joe Andreas took his own life. His art is seen here. The charity Hands In The Air ran a retrospective of his work to give him a debut at Hamilton House

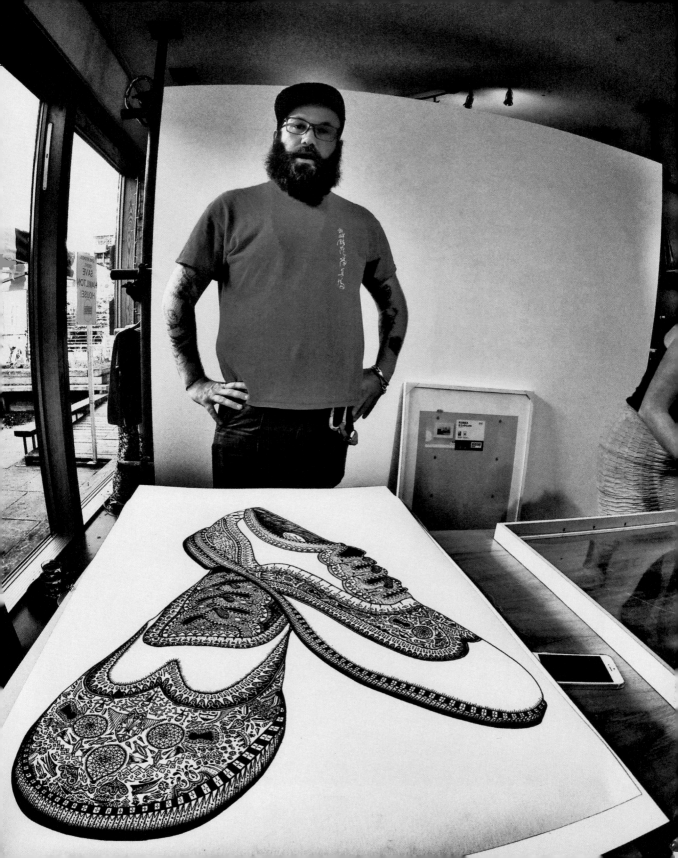

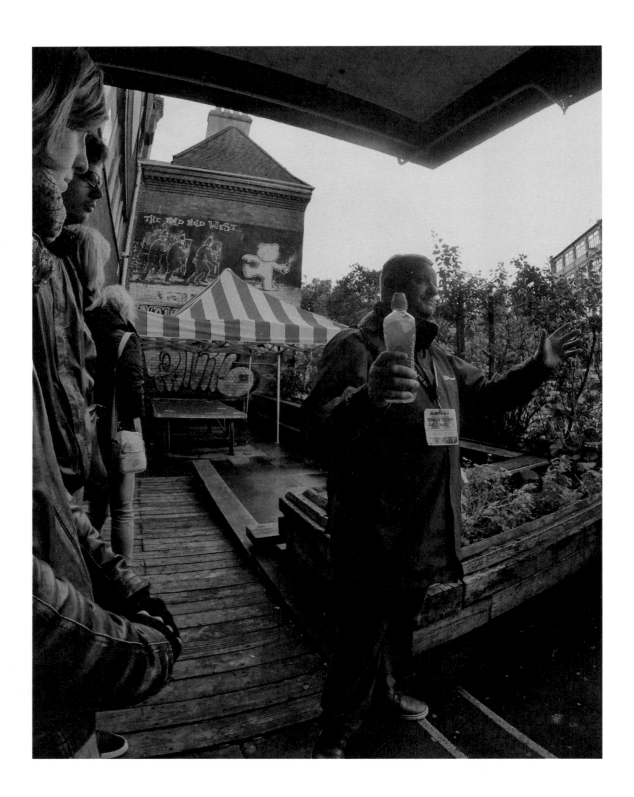

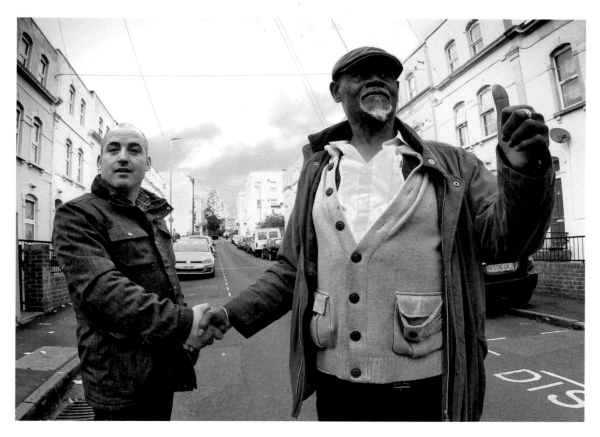

Ajax (right): 'Irish and black people always got on. We helped and supported each other. Always have.'

Opposite: John Nation running the street art tour. His energy drink by chance mirrors the Banksy bear in *Mild Mild West* artwork behind

Overleaf: Ajax and local *Rife* magazine team, St Paul's/Montpelier. 'You could offer me a flat in Buckingham Palace – I will always stay here.'

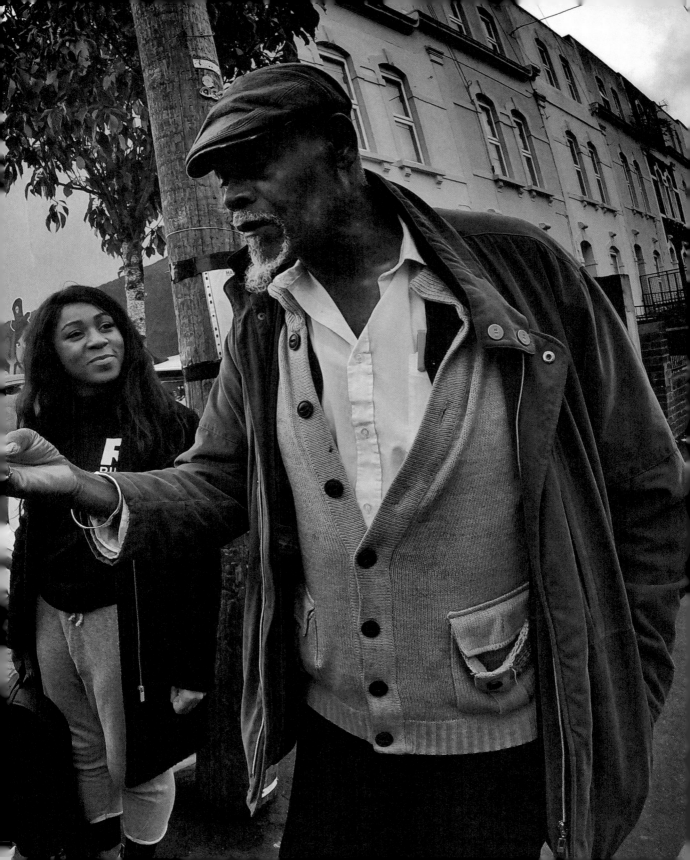

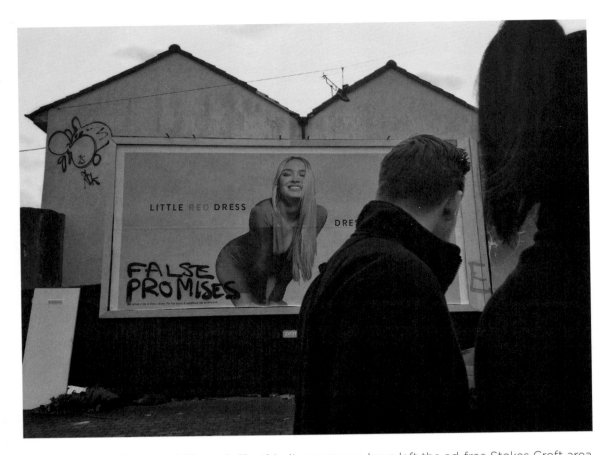

False Promises. If you see billboards like this, it means you have left the ad-free Stokes Croft area and wandered into St Werburgh's

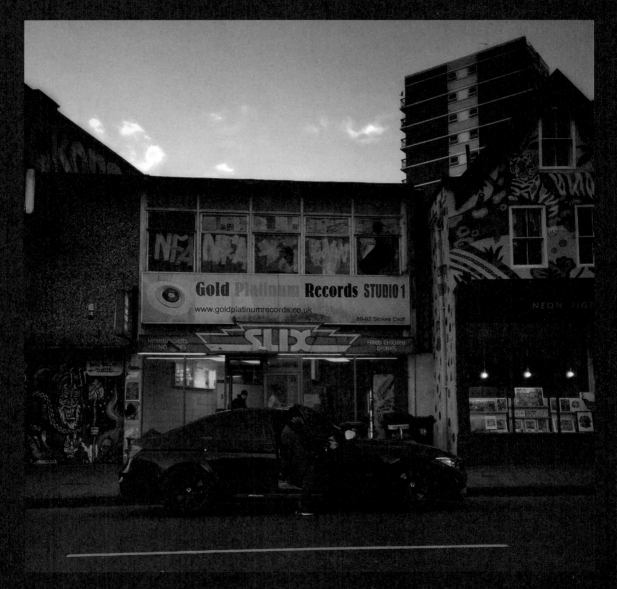

Song in my head: 'In my BMW, gonna get myself some Slix.'

High-rise fashion

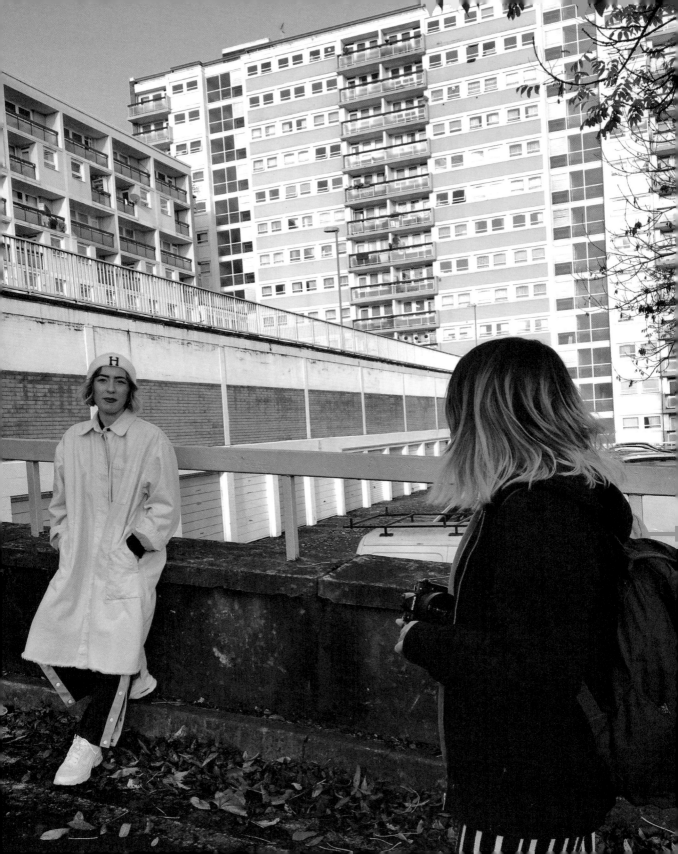

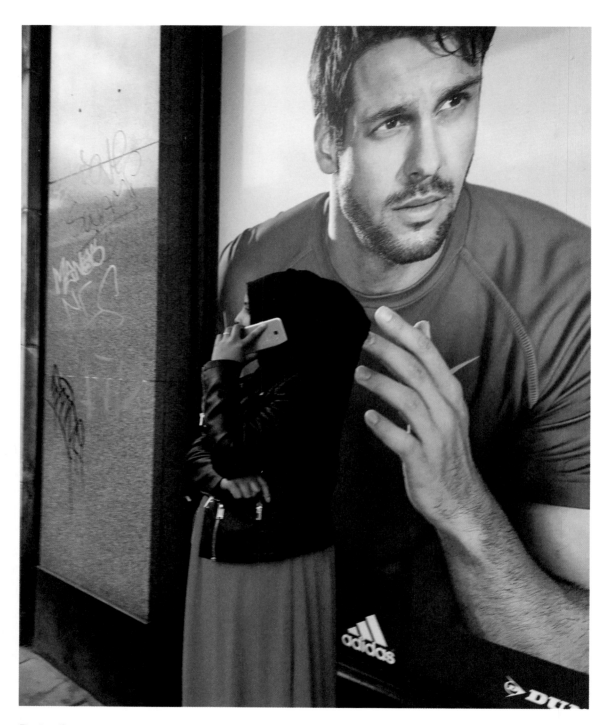

Protection

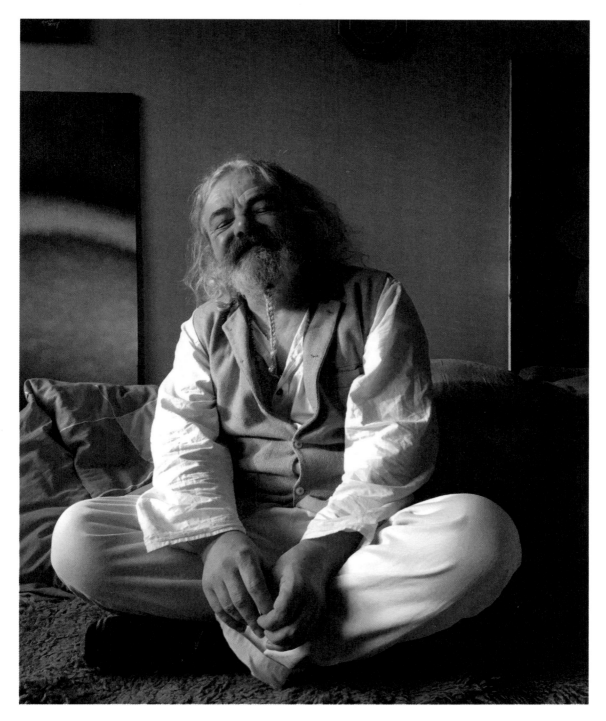

Martyn

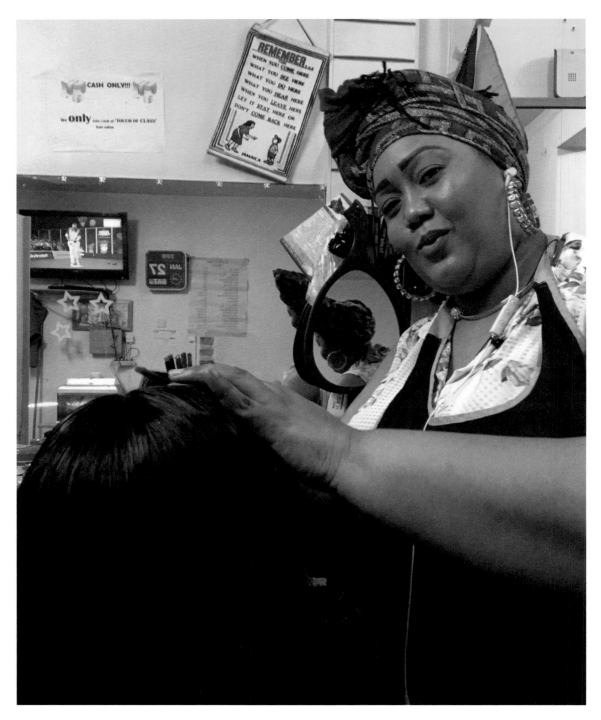

'Maxine. She's been doing our hair round here for decades.'

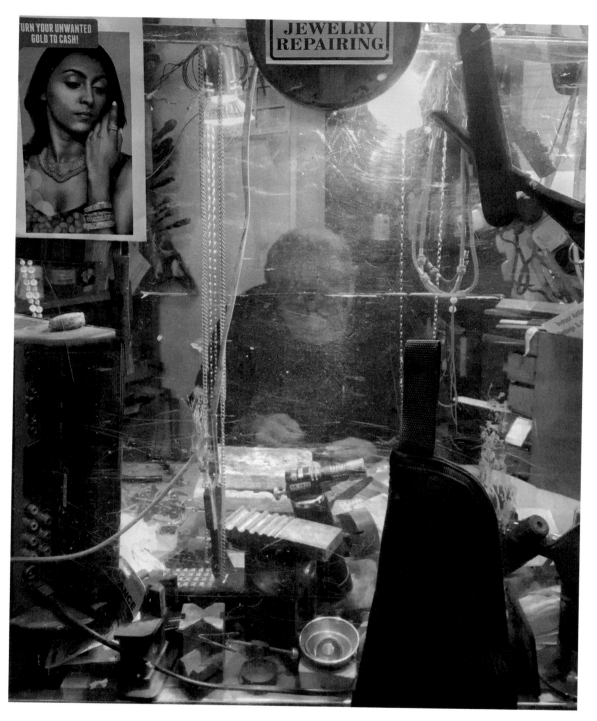

Keith, ex-army, in his late 80s, making jewellery in the vintage market

All the doctors, nurses and staff of Montpelier Health Centre. Part of my We Are One city-wide portrait project, where everyone's portraits are layered evenly over everyone else's in a group to find the 'one' face. This is an NHS face. A kind face

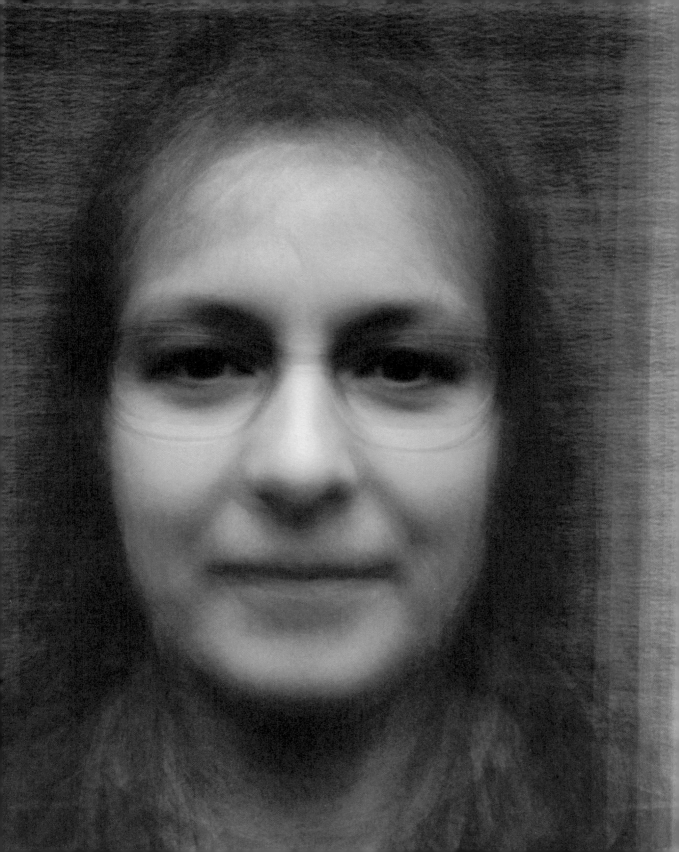

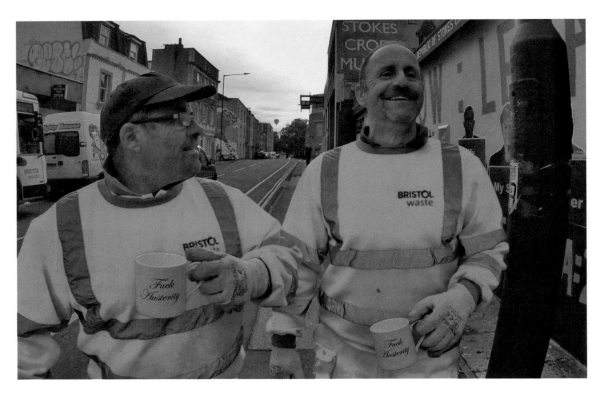

F*** Austerity

David wears Adidas. Jake from Blockwork (*right*) wears chinos

Overleaf: PRSC art ceramic workshop. The revolution will start with a cuppa in your clenched fist

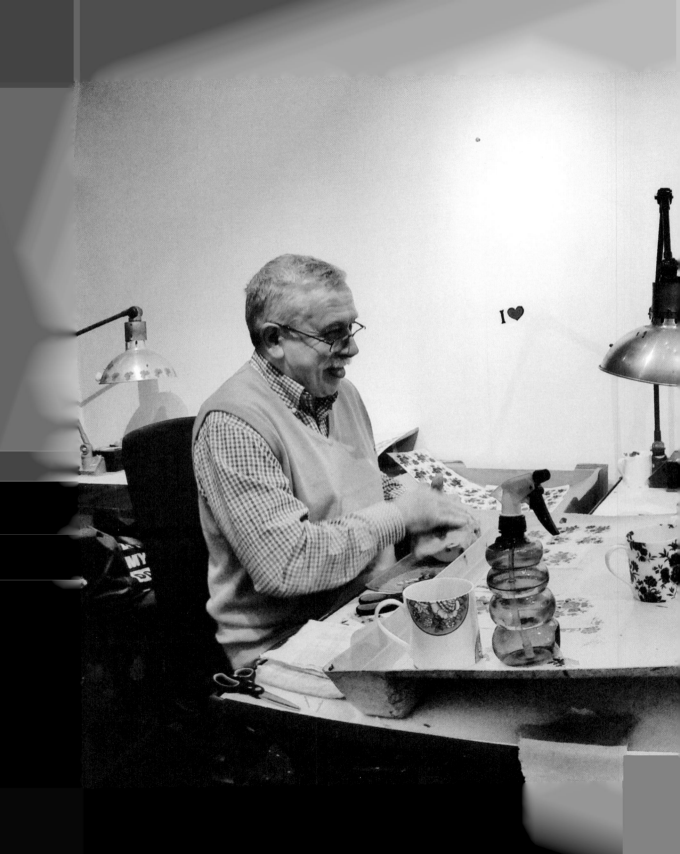

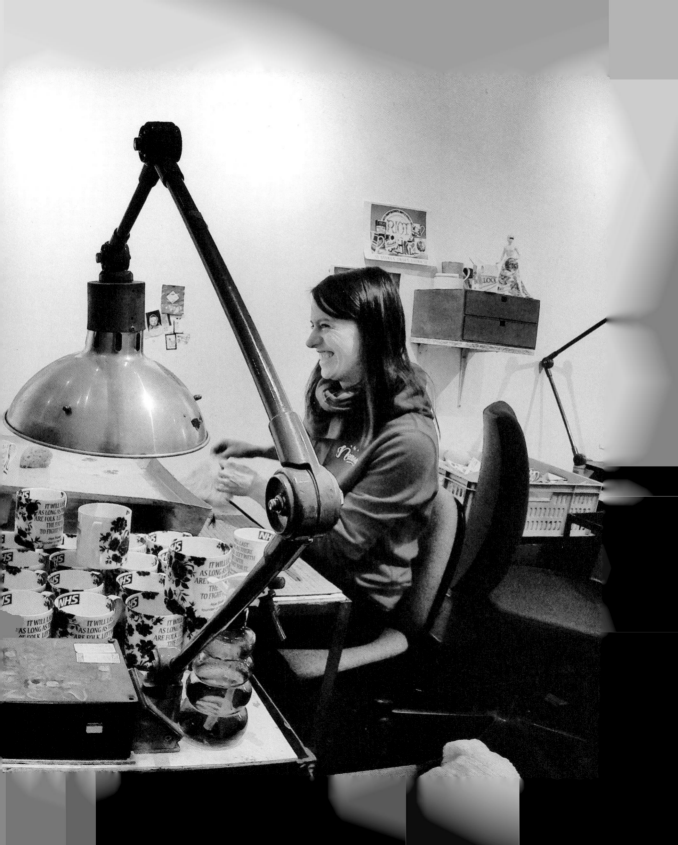

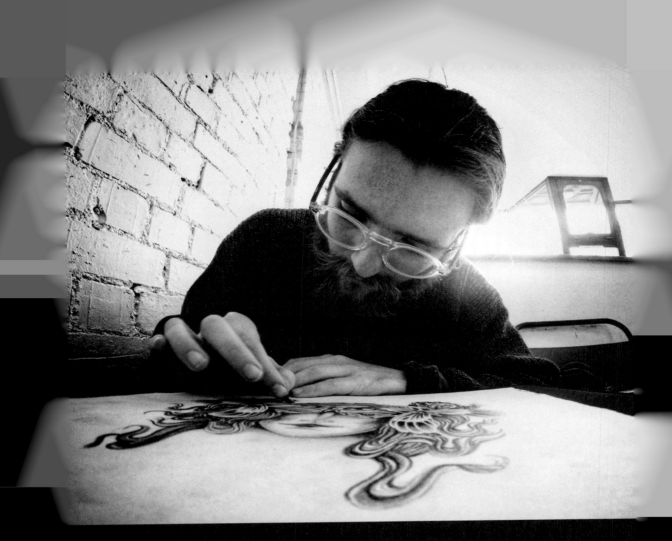

Tattooist Rich Henson in Cafe Kino

Opposite: James, Elevator Sound, with his modular synthesisers, drum machines and things

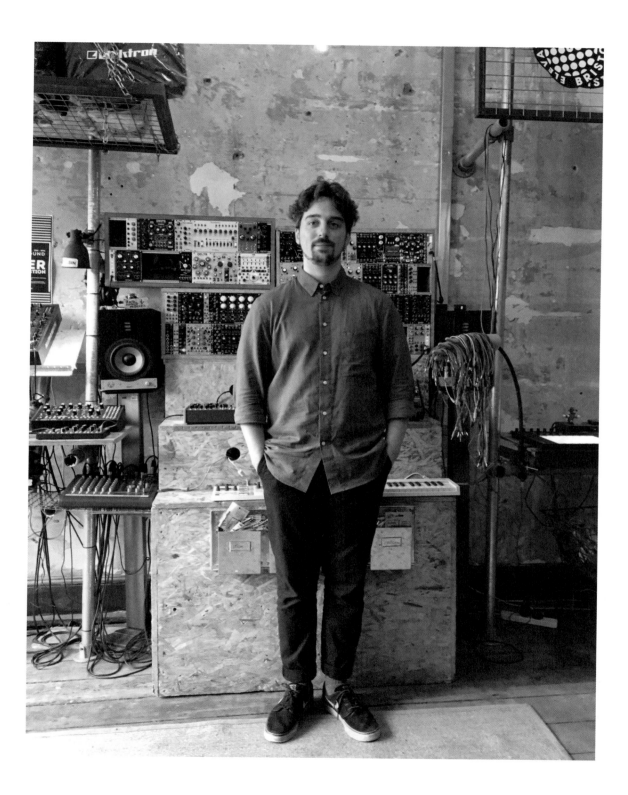

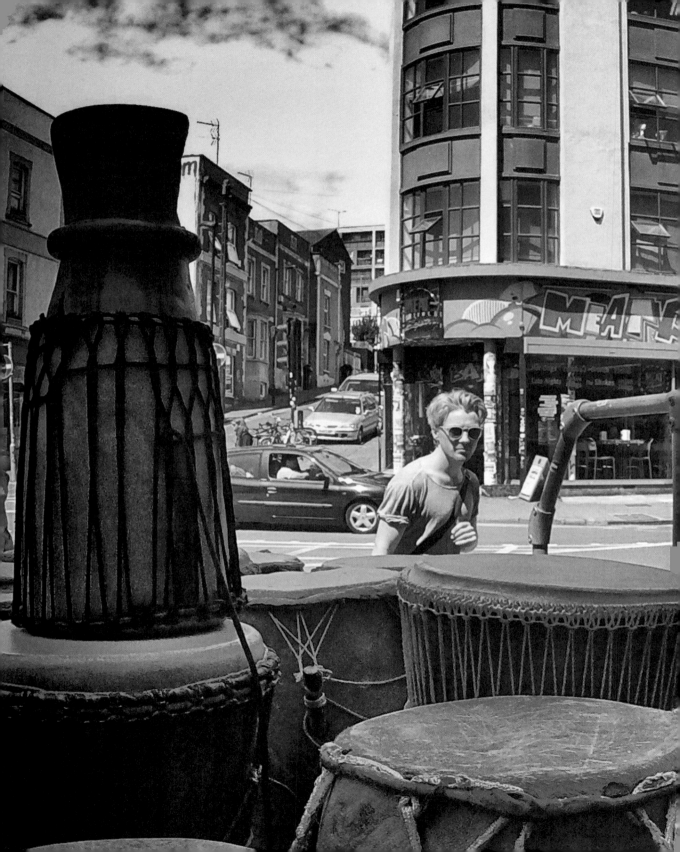

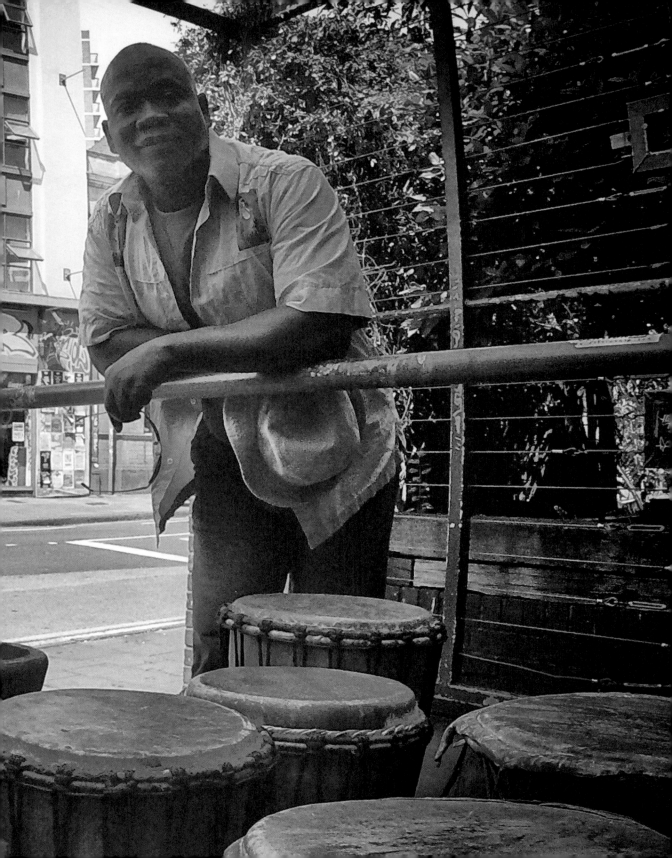

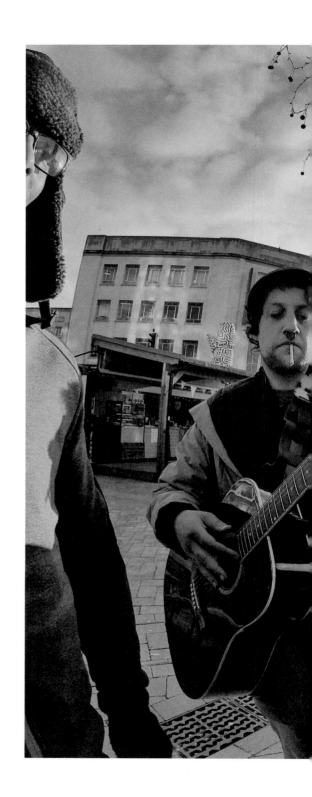

Andrew, Henry, James and their friends share music in the Bearpit. Henry (*right*) spitting lyrics: 'Life has got me walking through the hardest maze ...'

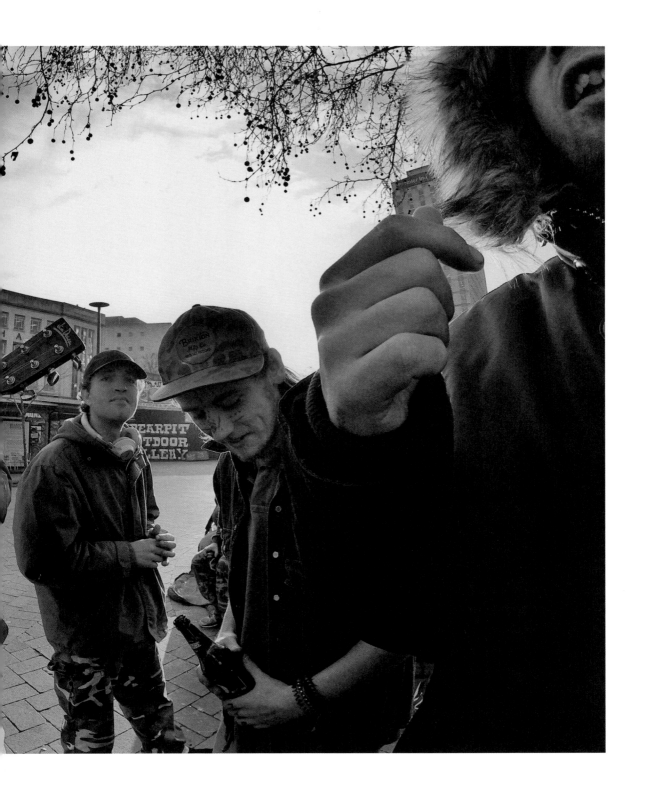

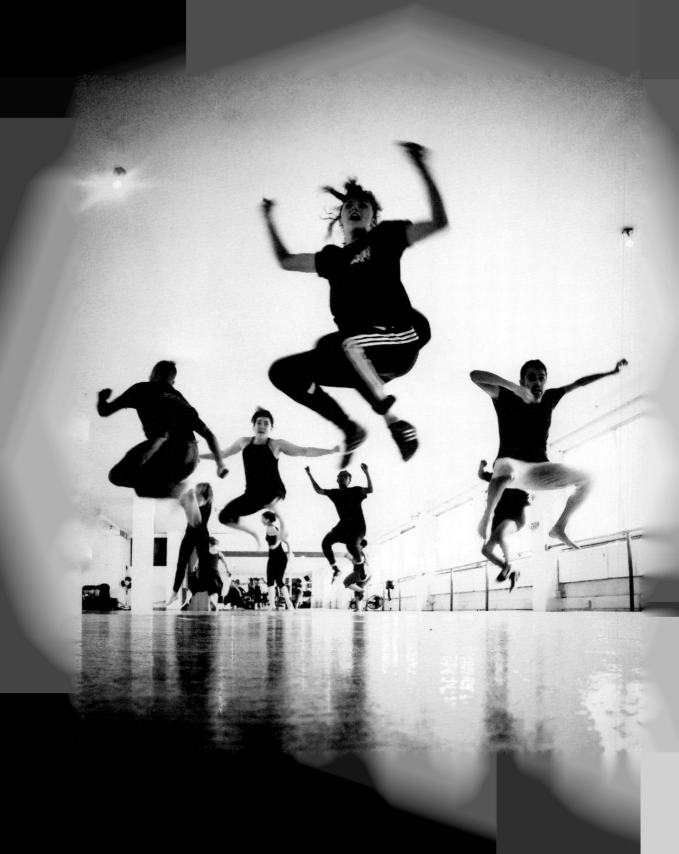

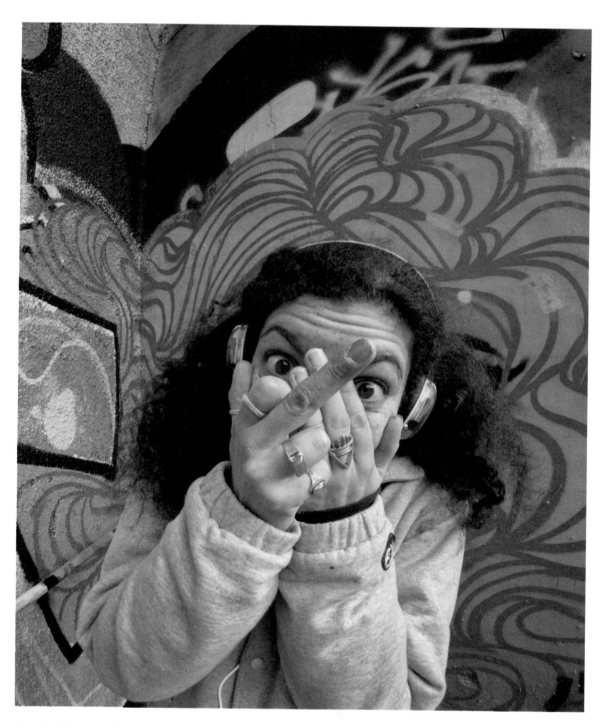

Sneak Pekoe, artist

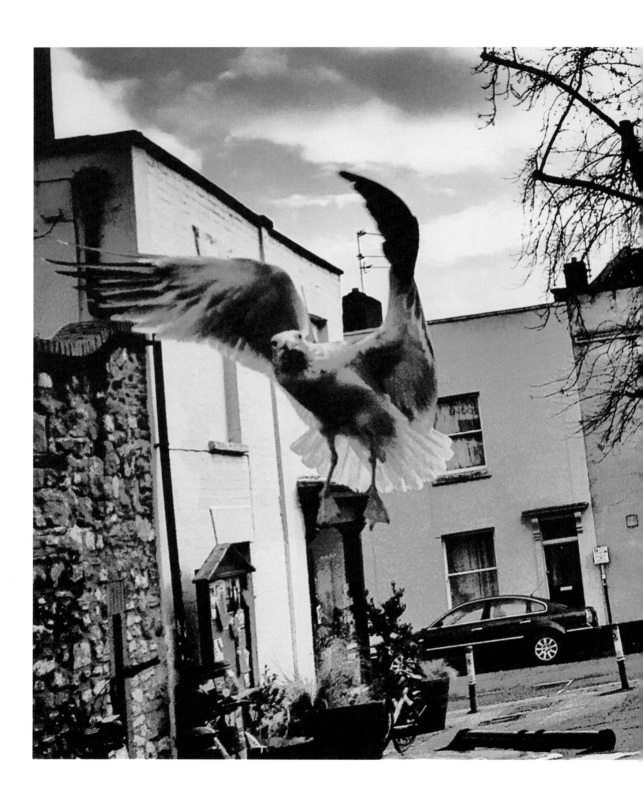

'You want a piece of me?' Picton Street

Right: Guitars into infinity.
Mickleburgh Musical instruments

Overleaf: Stokes Croft artists. Bernie
(*right*) tells me he worked as a farrier
and wants to teach foundry skills to
others. He has hope for his future here

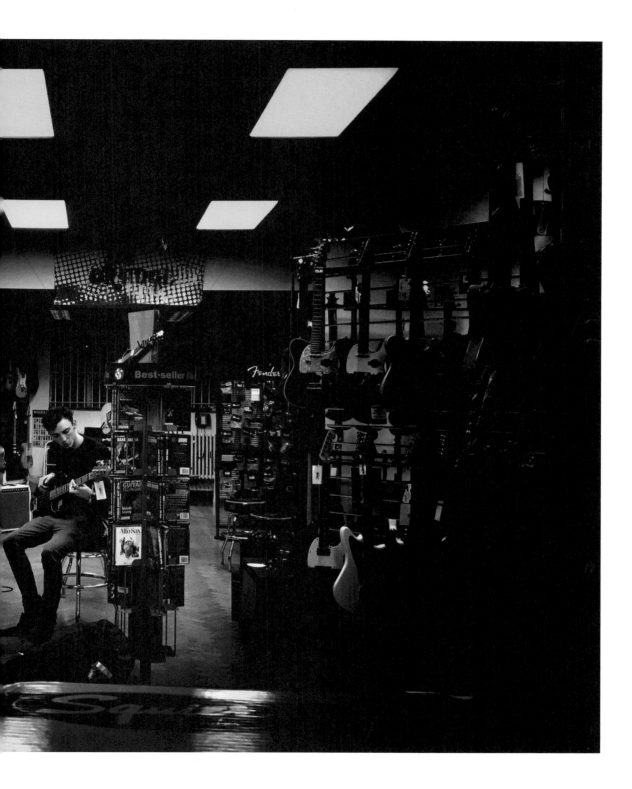

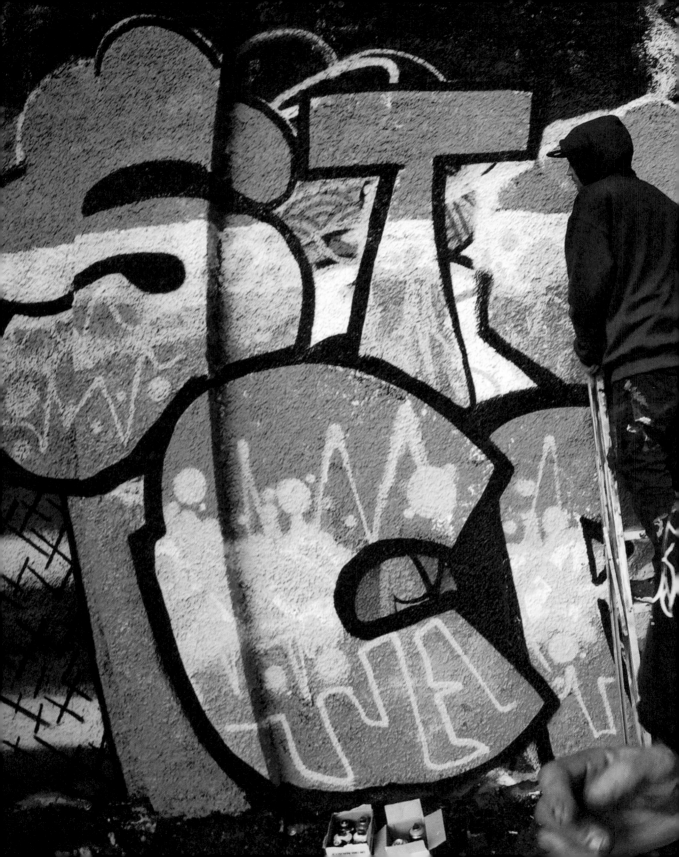

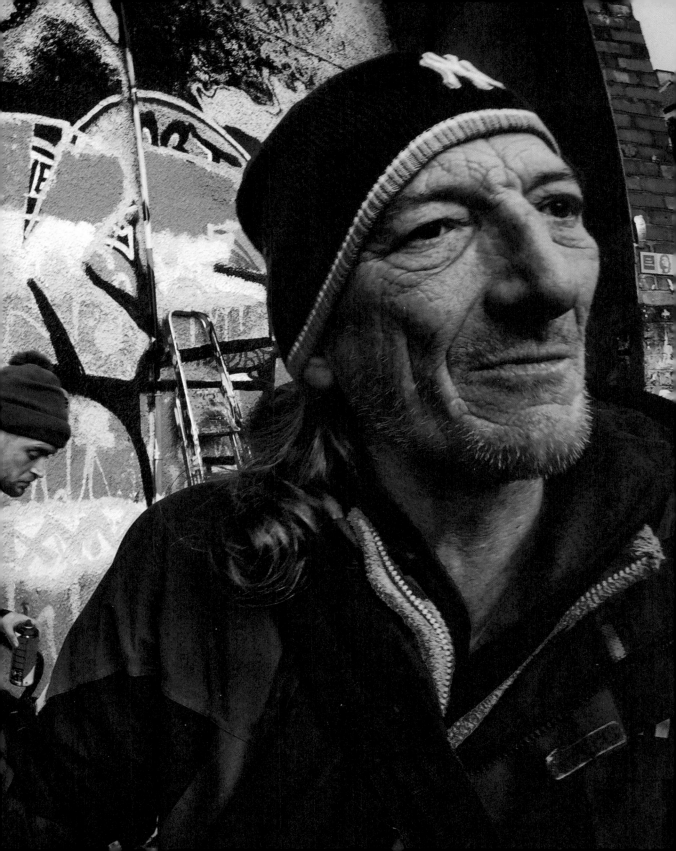

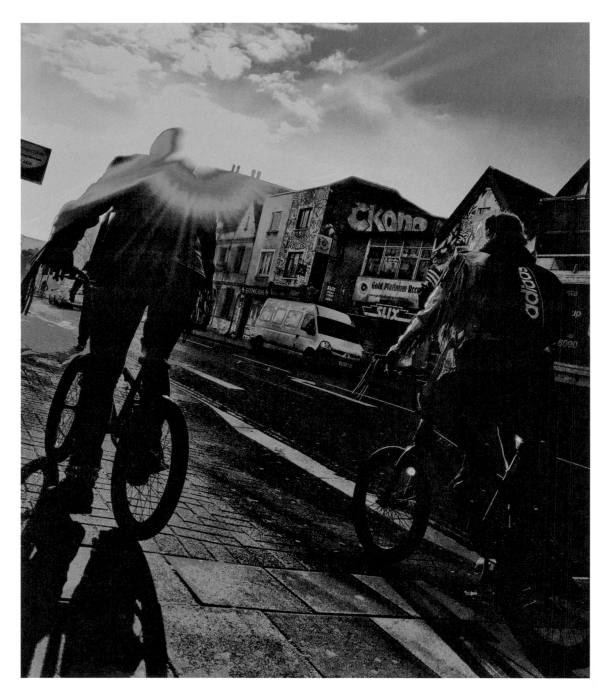

BMX angels

Overleaf: Coming home, Picton Street

Waiting

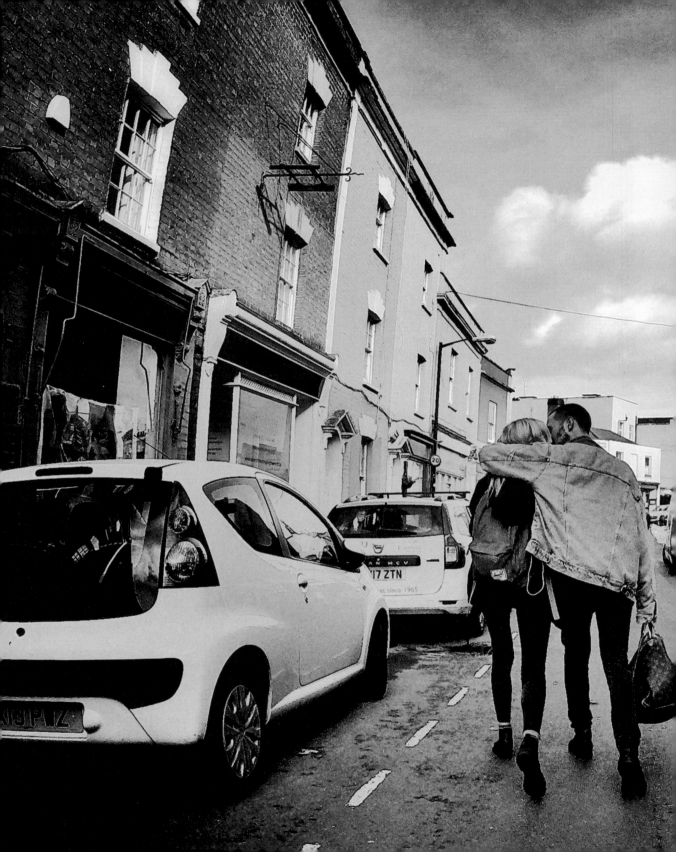

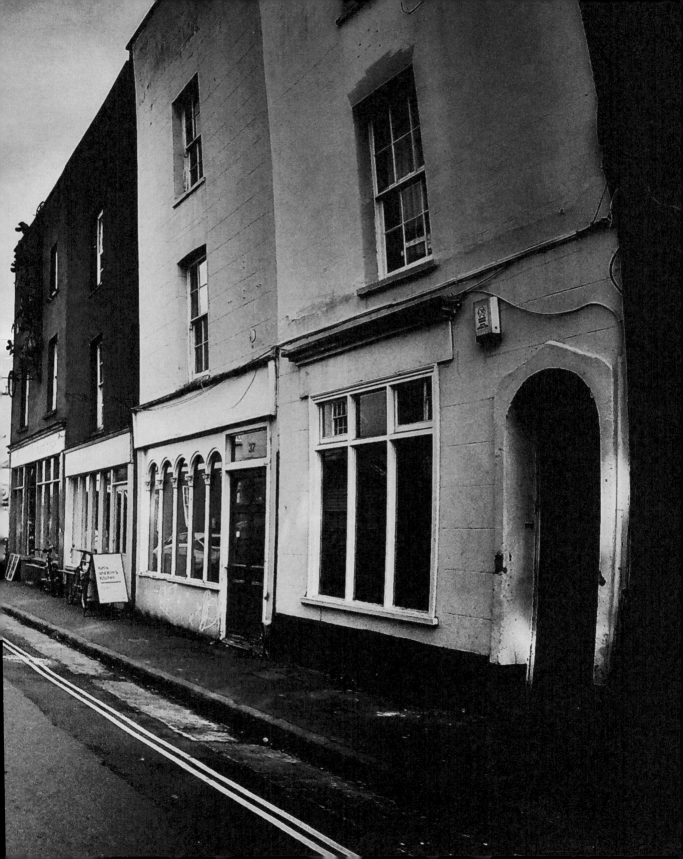

Lilian Looloutai, Maasai woman, at an
African Initiatives event in Montpelier. In her
country she is not allowed to speak at village
meetings. Men hold the talking stick

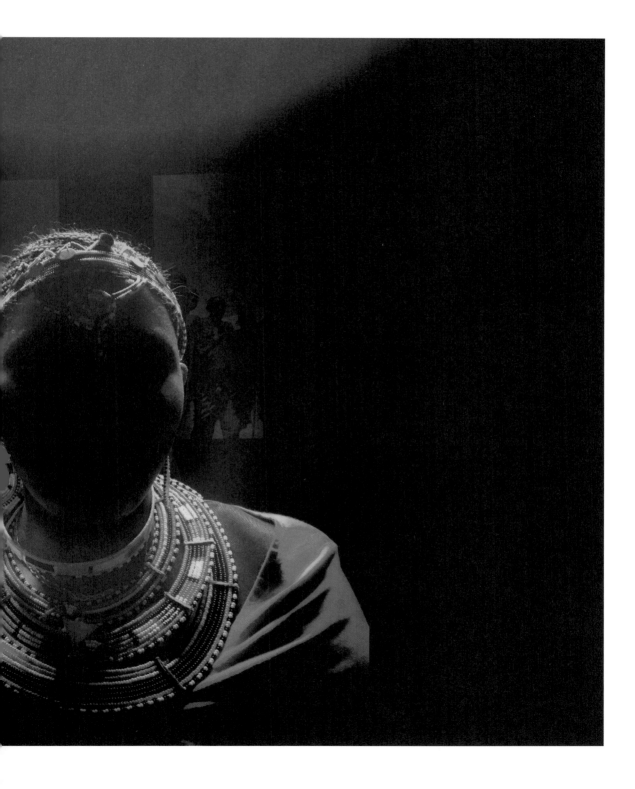

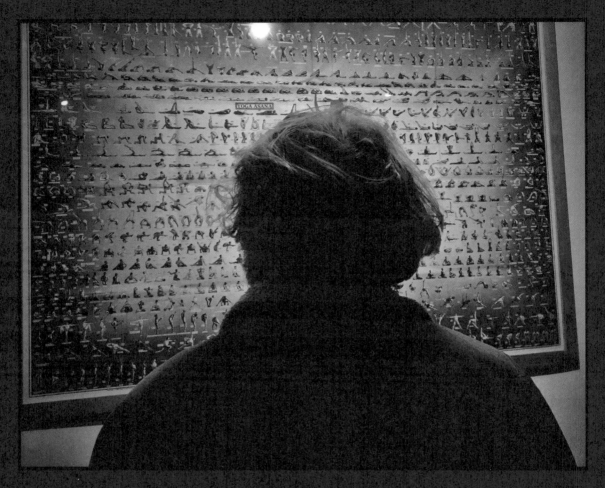

Yoga overload

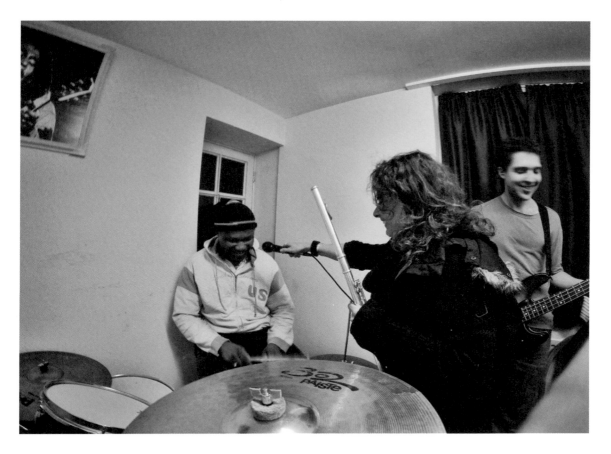

Barrington sets the beat. Music jam with some of the Bristol Reggae Orchestra

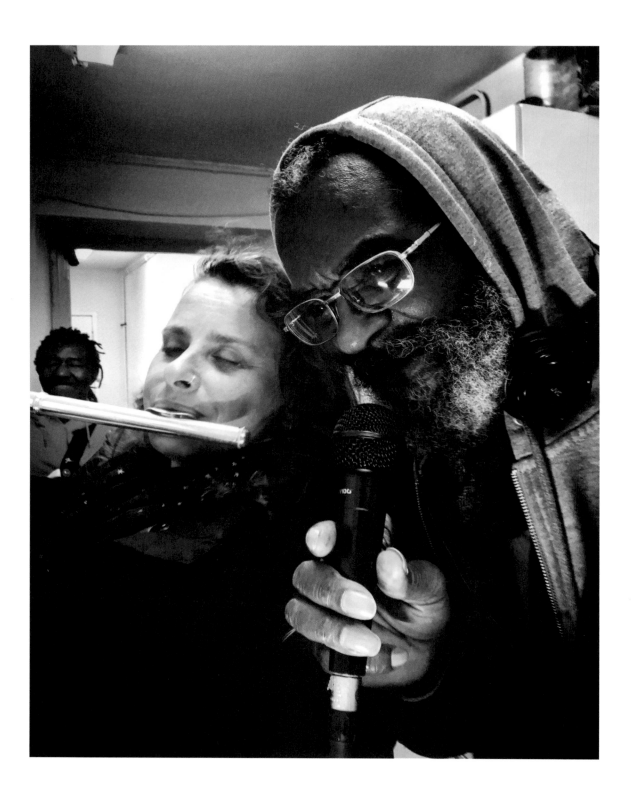

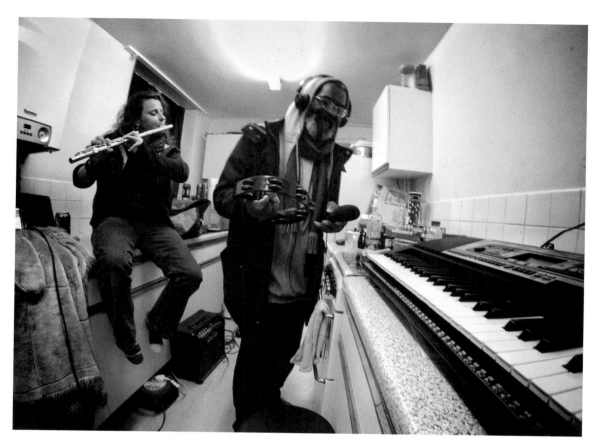

There's Reggae in my kitchen
What am I gonna do?
Join in!

Opposite: Rachael and The Professor 12 minutes into a song

Auction assistant raises up DJ Derek artwork

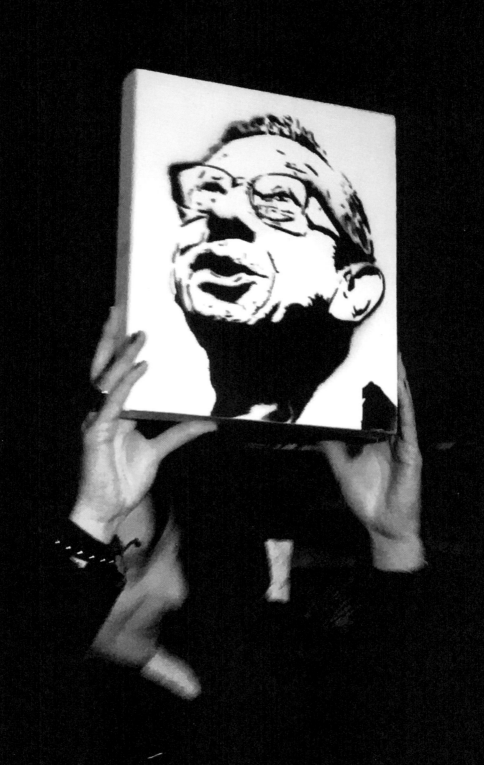

DJ Derek's art auction, between bids

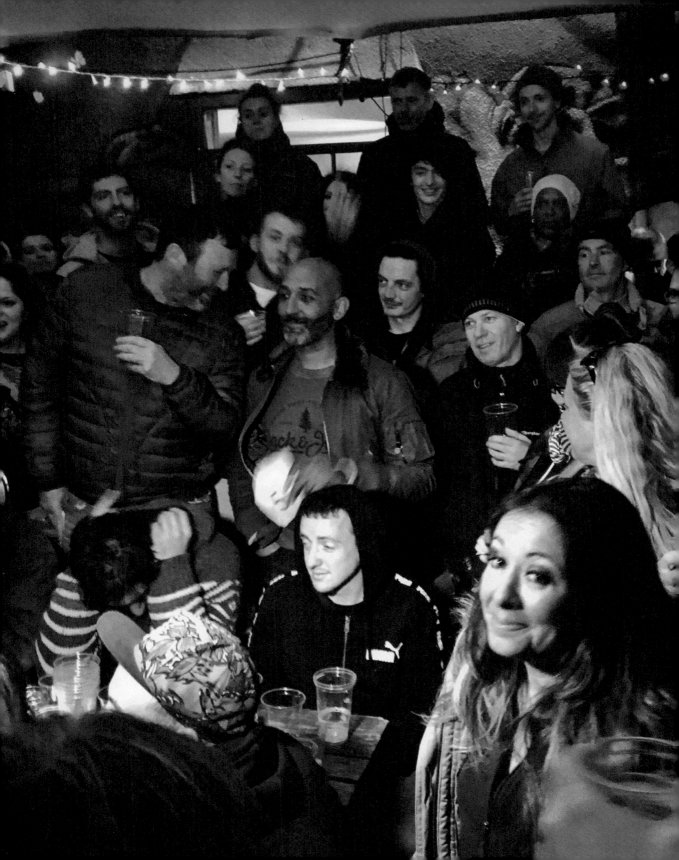

Mates

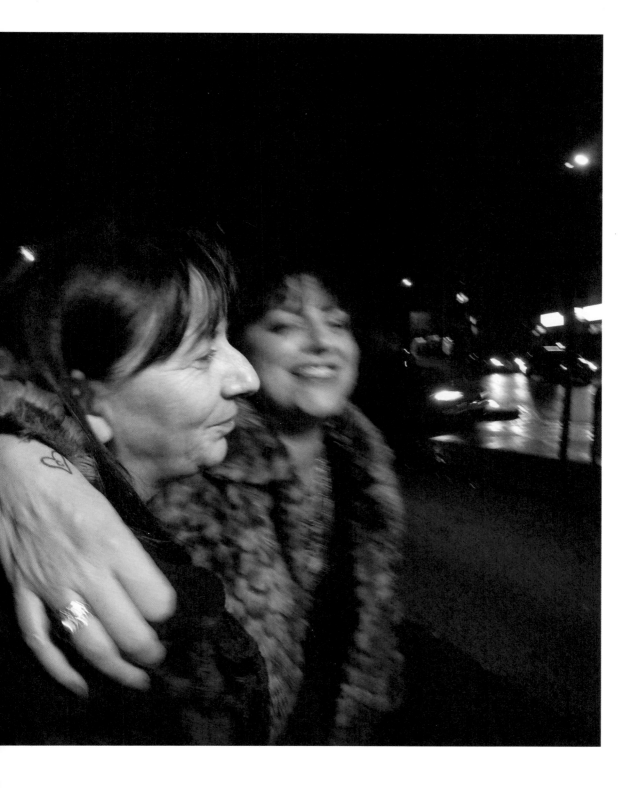

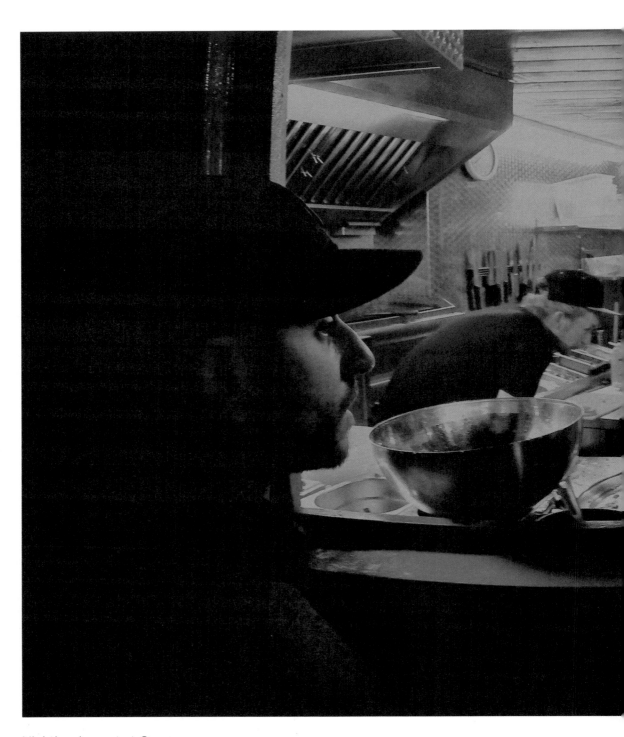

Nighthawkes eat at Oowee

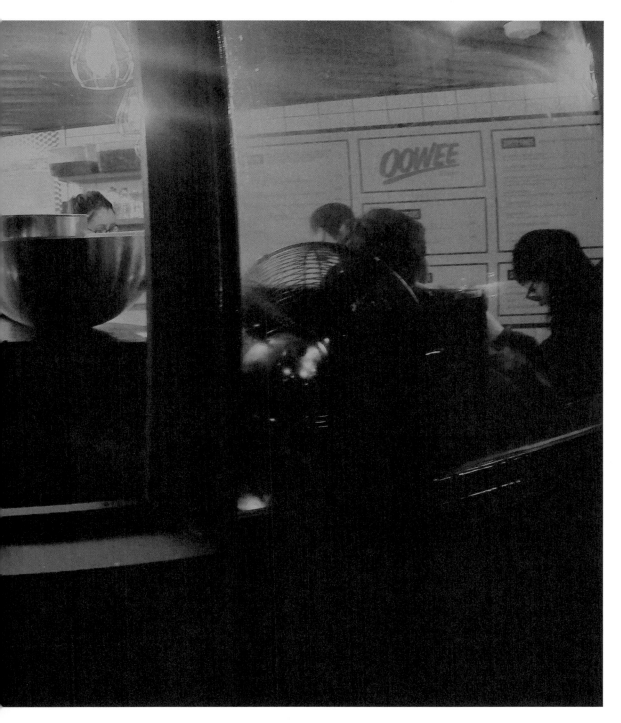

Overleaf: Night. Another world.

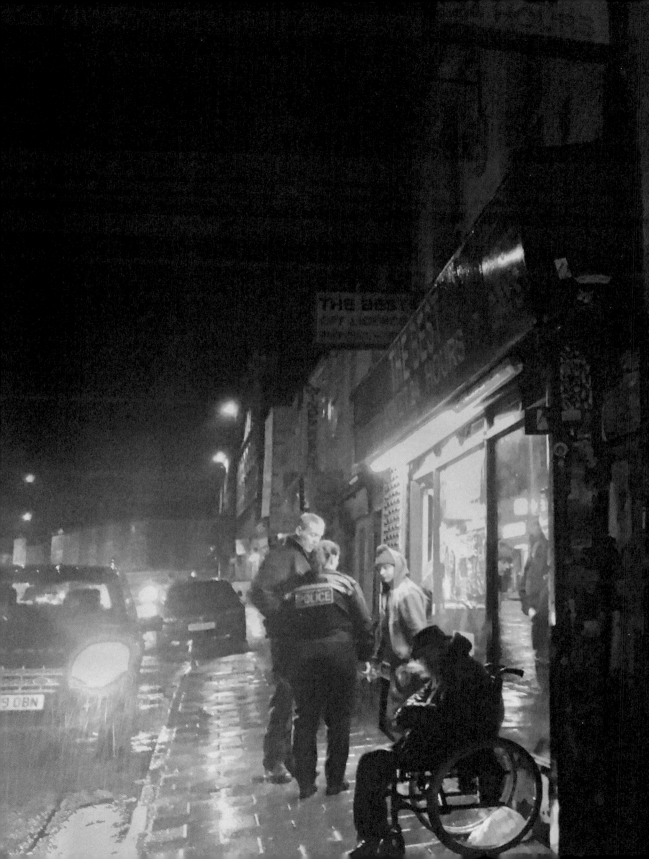

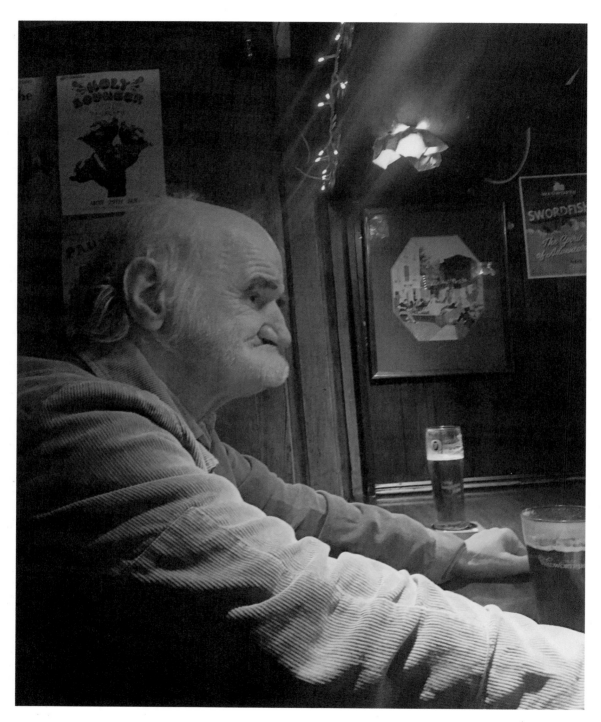

Phil waits for his brother Alf at the bar of the Old England in Montpelier

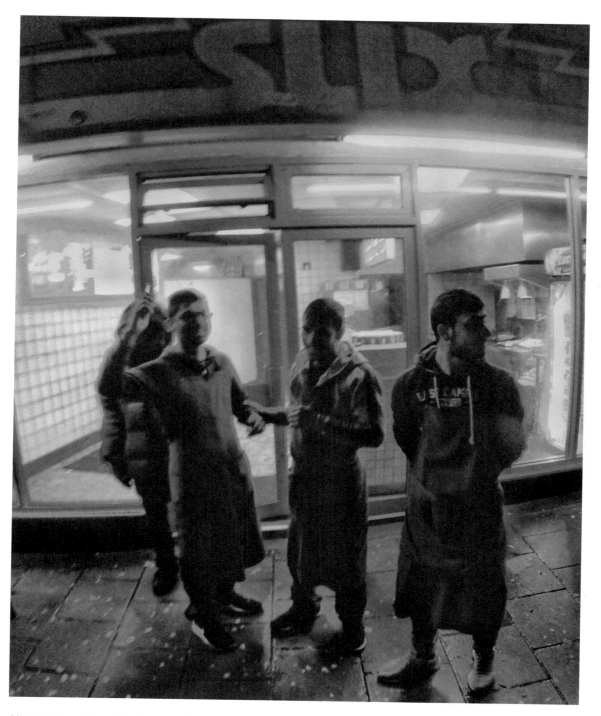

Slix, 12:01 on New Year's Day, 2018

Overleaf: Meet me further on down the road. Double exposure

Thanks for coming. Come back soon

Overleaf: Community

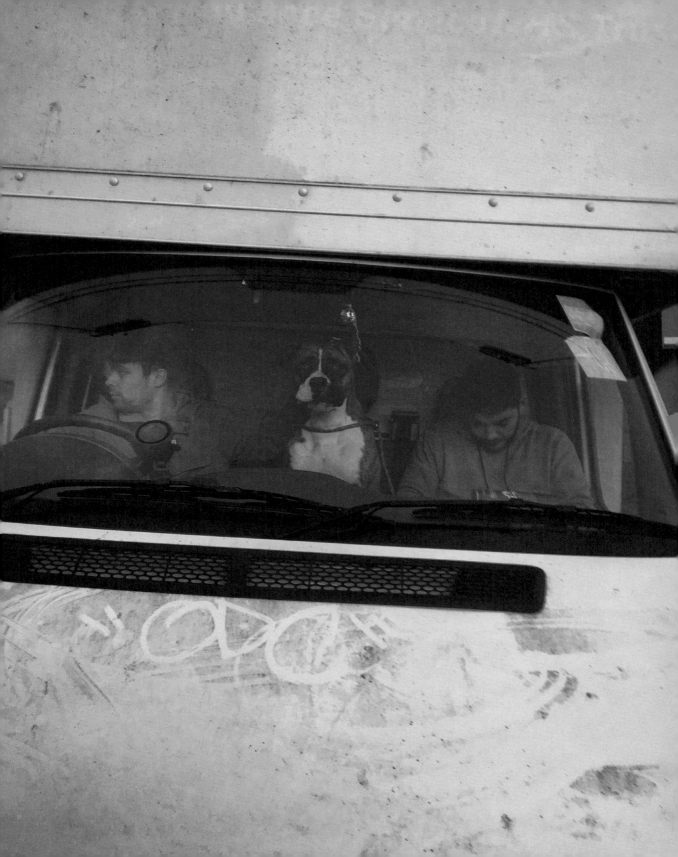

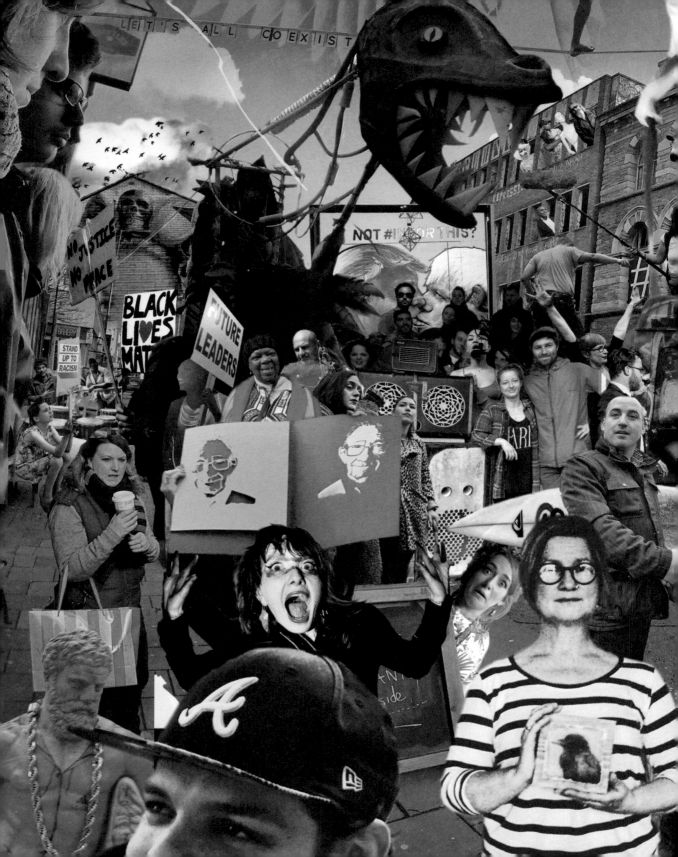

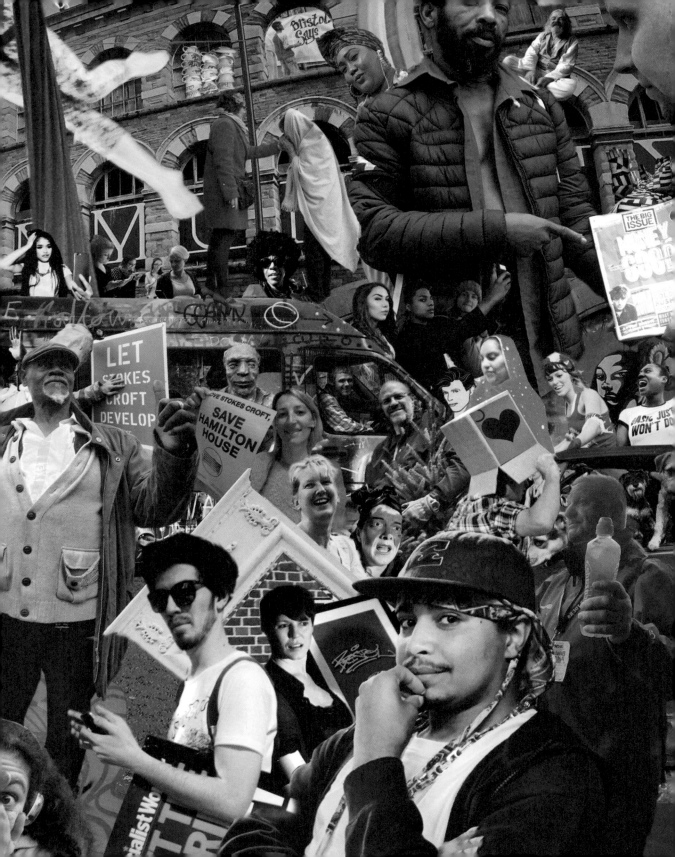